LEGENDARY LOCALS

OF

GREENE COUNTY
NEW YORK

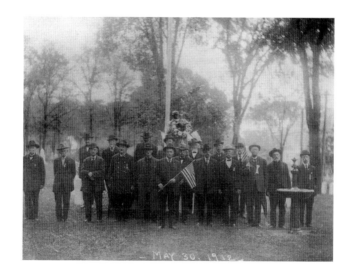

MAY 30. 1912.

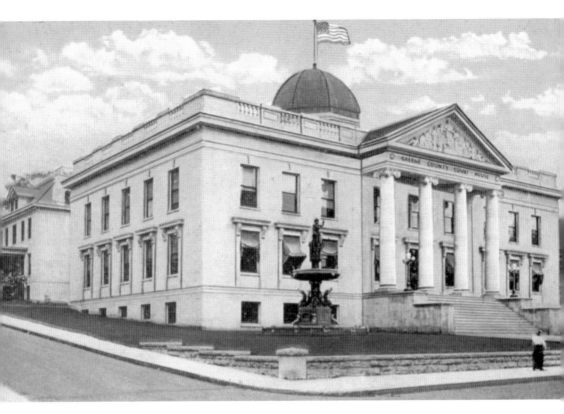

Greene County Court House
The Greene County Court House was built in 1910, and renovations were completed in 2012. (Courtesy of Greene County Historical Society.)

Page 1: Civil War Veterans
This gathering of Civil War veterans of the Grand Army of the Republic at the Civil War monument took place in Thompson Street Cemetery, Catskill, New York, on Memorial Day, May 12, 1912. (Courtesy of Emerson Martin.)

LEGENDARY LOCALS

OF

GREENE COUNTY

NEW YORK

DAVID DORPFELD AND WANDA DORPFELD

LEGENDARY
LOCALS

Legendary Locals is an imprint of Arcadia Publishing
Charleston, South Carolina

Printed in the United States of America

Library of Congress Control Number: 2013955328

For all general information, please contact Arcadia Publishing:
Telephone 843-853-2070
Fax 843-853-0044
E-mail sales@arcadiapublishing.com
For customer service and orders:
Toll-Free 1-888-313-2665

Visit us on the Internet at www.arcadiapublishing.com

On the Cover: Clockwise from top left:
Dynabil Industries longtime owners Hugh Quigley and Michael Grosso (Courtesy of Hugh Quigley; see page 108), Maude Adams, who played Peter Pan on Broadway over 1,500 times (Courtesy of Library of Congress; see page 55), Rubén and Corinne Garcia, nationally known flamenco dancers (Courtesy of Francesca Pratton; see page 58), Gen. Nathanael Greene (Courtesy of Greene County Historical Society; see page 12), Mohican chief Sachem Etowohkoam (Courtesy of Shirley W. Dunn; see page 10), Barbara Matera, designer of Hillary Rodman Clinton's gown for her husband's first inauguration ball (Courtesy of Jared Aswegan; see page 65), Charles Swain, Greene County minorities historian (Courtesy of Charles Swain; see page 46), Jane Barry, author of six novels (Courtesy of Doubleday & Company, Inc.; see page 34), Rip Van Winkle as played by Joseph Jefferson (Courtesy of Greene County Historical Society; see page 13).

On the Back Cover: From left to right:
The 77th New York Regimental Balladeers, Civil War musicians (Courtesy of John Quinn; see page 68), Larry Lane, longtime New York state assemblyman with former governor Nelson A. Rockefeller (Courtesy of Eleanor Lane, see page 86).

CONTENTS

ACKNOWLEDGMENTS

The authors gratefully acknowledge the Greene County Historical Society's Vedder Research Library for providing a substantial amount of the research material and many of the images used in this book. They also wish to extend a special thank-you to Jennifer Barnhart, the historical society's operations manager, for her technical assistance

In addition, we would like to thank the following people and organizations for their suggestions, photographs, and support: Scott Adams, *Albany Times Union*, Timothy Albright Jr., Timothy Albright Sr., Debbie Allen, Jared Aswegan, Dmitri Belyi, Carrolyn Bennett, Kevin Berry, Robert Beyfuss, Erica Brantley, Dick Brooks, Emily Brunner, Lynn Brunner, Richard Bruno, Clesson and Jean Bush, Cairo Historical Society, Robert Carl, Catskill Mountain Foundation, John Paul Filo/CBS News, Marge Chaloner, Candace Christiansen, James Coe, *Columbia-Greene Media*, Coxsackie-Athens Central School, V.T. Dacquino, Robert D'Agostino, Dave Darling, Karen Deeter, Patrick Downey, *Duellen* by Knud Leif Thomsen, Shirley W. Dunn, Durham Center Museum, EchoStarmaker.com, Larry Federman, Aaron Flack, Francis Burns United Methodist Church, Fabian P. Garcia, Theron Gunderman, Robert and Ann Hallock, Steve Hartman, Sylvia Hasenkopf, Heermance Memorial Library, J. Theodore Hilscher, Alvena Hitchcock, Iron Mountain, Perry Jones, William Knaust, Joe and Kate Konopka, Cindy Kornmeyer, Daniel Lalor, Library of Congress, Emerson Martin, Sandy and Renee Mathis, Shelby Mattice, Eric Maurer, Shirley McGrath, Denise Meehan, Stuart Moon, Tracey and Roger Moore, Nick and Mary Lou Nahas, Dick Nelson, Janet Nelson, Susan Neugebauer, New York City Landmark Preservation Commission, New York State Police, Seward R. Osborne, William Palmer, Jim Planck, Cornelia Porter, John Porter, Donna Poulin, Pratt Museum, Francesca Pratten, Jim Pulice, George Pulver, Michele Pulver, Hugh Quigley, John Quinn, Michael Rausch, Nancy Reynolds, Barbara S. Rivette, Kathy Schongar, Kathie Schulz, Stephen Shadley, David Slutzky, Wayne Speenburg, Kay Stamer, Ned Stiefel, George Story, James Story, Matthew Story, Charles Swain, Hudson Talbott, the Thompson family sisters, Doug and Sancie Thomsen, Dede Thorpe, Robert and Johanna Titus, Alice Tunison, United States Army, Bronk Van Slyke, Edgar Van Slyke, Waltham Museum, Florence Warren, James Warren, Stanley Whitbeck, and Mary Lou Zimmermann.

INTRODUCTION

With the Catskill Mountains on the west and the beautiful Hudson River on the east, Greene County is one of the most picturesque places in New York State. Native Americans had settlements close to the river for centuries and quarried flint for tools and weapons there as well. Shortly after Henry Hudson claimed the land for the Dutch East India Company in 1609, settlement by Europeans began. Pieter Bronck's home in Coxsackie, built in 1663, survives as the oldest house in upstate New York and stands as a testament to early Dutch influence. Early on, the county's economy was primarily agricultural with a few small water powered mills and most settlements located near the river. Farming took place on the flatter land east of the mountains.

With the exception of some Tory and Indian raids, no battles were fought in Greene County during the Revolutionary War. There was strong support for the Colonial cause, however, as evidenced by the Coxsackie Plan of Association signed by 220 patriots in 1775. Over the course of the war, the county also provided soldiers and materiel to support the fight. Local men like Domine Johannes Schuneman, Leonard Bronck, Anthony Van Bergen, and Philip Conine Jr. played important roles in support of the Colonial cause.

After the Revolution, mountainous area began to be widely settled with a large influx of people from New England and the county was established from parts of Albany and Ulster counties in 1800. State chartered and privately financed turnpikes also came on the scene with the dawn of the 19th century and helped form pathways for trade and westward migration. The most famous in Greene County was the Susquehanna Turnpike that stretched from Salisbury, Connecticut, to Unadilla on the Susquehanna River. Passing through Catskill and the heart of Greene County, it was a great thoroughfare for a time until the Erie Canal came along in 1825 and railroads began to arrive on the scene around the middle of the century. Shortly after the turnpikes started to be built, steamboats also came into wide use on the Hudson River, saving countless hours in shipping and transportation. These two innovations, turnpikes and steamboats, led to significant commerce and development for the river towns of New Baltimore, Coxsackie, Athens, and Catskill.

Industries sprung up in Greene County during the first half of the 19th century as well—ice harvesting on the river, shipbuilding, leather tanning, and brick and pottery making all started at this time. Docks in all the river towns also gave agricultural producers a convenient way to get their products to market. Another industry that emerged in 1824 was the tourist industry with the opening of the iconic Catskill Mountain House. From there, Greene County went on have hundreds of hotels and boardinghouses, which accommodated summer visitors. This was also a time when artists discovered the beauty of Greene County and Thomas Cole, recognized as the founder of the Hudson River School of Art, made his home in Catskill for almost two decades until his death in 1848.

Some of the major industries mentioned continued into the 20th century, but with the exception of tourism, all are gone today. The county is still a major vacation area with a change of focus from the earlier times. No longer are most visitors content with a quiet two-week stay at a hotel or boardinghouse in the Catskills. Today, the county gets many day travelers along with people that have second homes they often use for weekend getaways. Two major ski areas in Windham and Hunter attract many visitors because of their proximity to the New York City metropolitan area. While there is still some manufacturing in Greene County such as GlaxoSmithKline (the former Steifel Laboratories, Inc.) in Oak Hill and Ducommun Aerostuctures (the former Dynabil Industries) in Coxsackie, many of the full-time residents of the county now work in service industries, such as government and retail, or commute to jobs in the Albany area.

A book this size presents some limitations for writers. For one, it forced us to be selective about the people we included. We know we could have included many more local heroes who have left their mark on Greene County and other places, but we had to stop somewhere. Also, the biographies are short. We hope they will spur your interest to learn more about some of them through your local library or the Internet. For us, we found the Greene County Historical Society's Vedder Research Library in Coxsackie to be a tremendous resource for researching local people. If it were not for people like Charles Dornbush and Raymond Beecher, both of whom are included in the book, this wonderful facility would not be available to the public.

Bronck Family
The 1663 Bronck House, with later additions, is seen here from the West Bank of the Coxsackie Creek. Eight generations of the Bronck family owned the property, which was purchased from the Native Americans. (Authors' collection.)

CHAPTER ONE

Founders, Firsts, and Icons

The first Europeans set foot in what is now Greene County over 400 years ago. Before that, the area was populated by various groups of Native Americans. Today, these peoples have vanished. In this chapter, the authors have attempted to highlight people who have made a contribution to the county or American life in some way because they were either a founder, they were the first to do something, or they are local or national icons. Founders include people such as Pieter Bronck, the first person to settle in Coxsackie; Thomas Cole, father of the Hudson River School of Art; and Candace Wheeler, a pioneer in the vacation cottage movement in the Town of Hunter. In the category of people who achieved firsts, the authors include Native Americans, Henry Hudson, Robert Fulton, and Levi Hill—the first person to achieve color photography. Greene County icons include "Uncle Sam" Wilson, who lived in Catskill for a time; the fictional Rip Van Winkle; and the well-known Red's Restaurant, founded by Red Mays and a fixture for Greene County people for seven decades.

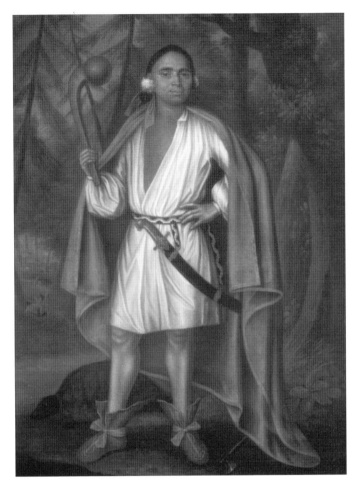

Native Americans

By the early 19th century, Native Americans had virtually vanished from Greene County, but there is evidence that they were here over 10,000 years before Europeans first set foot in Greene County. The earliest were migrants or nomads and made their camps along the river and streams. They were big-game hunters known as Paleo-Indians, and remains of their camps have been found on West Athens Hill and on Kings Road in the Town of Catskill. It is believed that they mined their flint for weapons at Flint Mine Hill in Coxsackie, which is now on the National Register of Historic Places. The next group of Native Americans was known as the Archaic culture, and they were migratory hunters, fishers, and gatherers. Evidence of many of their campsites have also been discovered either on the Hudson shoreline or not far from it. As time went on, these native people began to learn something about agriculture, the making of clay pots, and settled in more semi-permanent villages. By the time Henry Hudson claimed the Hudson Valley for the Netherlands in 1609, the Native Americans in Greene County were settled in well-established villages of 200 or more individuals. In Greene County, the river valley was largely occupied by the Mohicans who lived from the southern tip of Lake Champlain south as far as present-day Catskill. Their villages stretched as far east as western Vermont, Massachusetts, and Connecticut. To the west of the river the mountains were not occupied and further on the Mohawks occupied the land. To the south, the Mohicans' neighbors were the Munsee Delaware. Descendants of the Mohicans, known as the Stockbridge-Munsee Band of Mohican Indians, now live in Wisconsin after being driven west as a result of European settlement. There are 1,600 people enrolled in the tribe. (Courtesy of Shirley W. Dunn.)

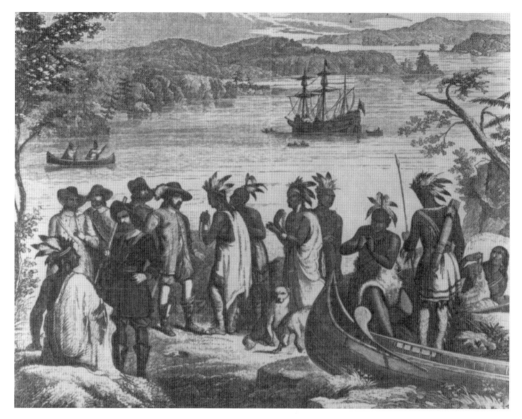

Henry Hudson (1565–June 12, 1611)
On September 10, 1609, Henry Hudson set sail up the river that would eventually be named in his honor. Robert Juet, the first mate of the *Halve Maen* (Half Moon), kept a written record of the voyage. On September 15, he writes that the crew was visited by the natives whom he called "very loving people." It is believed Juet's observation took place north of what is currently the Village of Athens. (Courtesy of Library of Congress.)

Pieter Bronck (1617–1669)
In 1662, Bronck acquired a parcel of land from Native Americans in what is now the Town of Coxsackie. Bronck, his wife, Hilletje, and young son Jan arrived at their new property in the spring of 1663 and built a small solid square home in a clearing near a shallow steam. Today, the original structure still stands and is recognized as the oldest surviving house in upstate New York. (Courtesy of Jim Planck.)

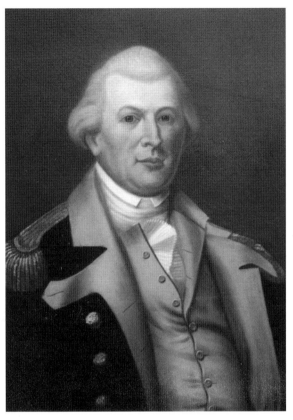

Nathanael Greene
(August 7, 1742–June 12, 1786)

Why is the county Greene? Greene County is named for the famous Revolutionary War general, Nathanael Greene. Why was General Greene so important that the county is named in his honor? It is because Greene played such an important role in winning the war and was considered by many as Washington's successor to lead the army, should Washington fall in battle. Despite the fact that Greene's family were Quakers and pacifists, he joined and drilled with a local militia known as the Kentish Guards when difficulties began to arise between England and the colonies. After the battles of Lexington and Concord, the Rhode Island General Assembly named Greene a major general and ordered a force of 1,600 men be formed under his command. By June 1775, Greene had his troops in position around Boston, and in July, George Washington arrived. Now, being part of the Continental Army, his rank was reduced to brigadier general. He served General Washington on Long Island, in New Jersey, and at the Battles of Brandywine and Germantown in Pennsylvania during 1777. During the winter of 1777 and 1778, General Greene was with Washington at Valley Forge and was appointed quartermaster general of the army. After General Gate's severe defeat at Camden, South Carolina, General Greene was appointed by Washington to take over the southern command, which stretched from Delaware to Georgia. Over the next two years, the general successfully led his troops in several battles that ultimately drove the British from the Carolinas and aided the American cause in Georgia. Greene, always short of men, money, and supplies, frustrated the British general Cornwallis to the point that he no longer headed an effective fighting force. When Greene heard that Washington had Cornwallis trapped in Yorktown, he wrote, "We have been beating the bush and the General has come to catch the bird." Nathanael Greene resigned his commission in August 1783 and moved to Georgia in 1785 to develop a plantation there. He died suddenly from what may have been a heat stroke on June 12, 1786, at the age of 44. His remains and those of his son George Washington Greene rest beneath an obelisk in Johnson Square in Savannah, Georgia. (Courtesy of Greene County Historical Society.)

Rip Van Winkle (1819)

Rip Van Winkle by Washington Irving is a story about a man of the same name who is living in a Dutch village at the foothills of the Catskill Mountains just before the American Revolutionary War. Rip loves to spend his time in the Catskill Mountain wilderness hunting with his dog and does not care much for keeping up his home and farm. One autumn day, Rip, escaping his wife's nagging, wanders up the mountains with his dog Wolf. While there, he meets a group of bearded men dressed in antiquated Dutch clothing, playing nine-pins . . . Although there is no conversation and Rip does not ask the men who they are or how they know his name, he discreetly begins to drink some of their liquor and soon falls asleep. He awakes in unusual circumstances: It seems to be morning, his gun is rotted and rusty, his beard has grown a foot long, and Wolf is nowhere to be found. Rip returns to his village where he finds that he recognizes no one. Asking around, he discovers that his wife has died and that his close friends have died in a war or gone somewhere else. Rip is disturbed to find another man is being called Rip Van Winkle (though this is in fact his son, who has now grown up). Rip learns that the men he met in the mountains are rumored to be the ghosts of Henry Hudson's crew. He is told that he has apparently been away from the village for 20 years. An old local recognizes Rip, and Rip's now-adult daughter takes him in. Rip resumes his habitual idleness, and his tale is solemnly taken to heart by the Dutch settlers, with other hen-pecked husbands, after hearing

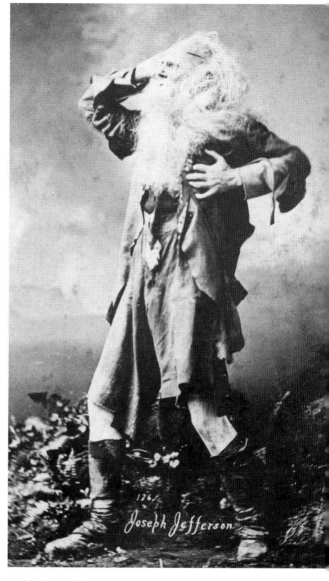

his story, wishing they could share in Rip's good luck, and have the luxury of sleeping through the hardships of the American Revolution. Despite the fact that Irving had never visited the Catskills at the time he wrote the story, Greene County has claimed Rip Van Winkle as their own since the mid-19th century. Evidence of this resides with the Rip Van Winkle House on the old stagecoach road to the Catskill Mountain House, the popular children's theme park of the 20th century called Rip's Retreat and the Rip Van Winkle Bridge that connects Greene and Columbia Counties. (Courtesy of Greene County Historical Society.)

Leonard Bronck (1751–1828)

Bronck is probably the highest achieving of the eight generations of the family that owned the Bronck property in Coxsackie. He was a surveyor, attorney, farmer, state assemblyman and senator, the first judge of the Court of Common Pleas for Greene County, and signer of the Coxsackie Plan of Association prior to the Revolutionary War. With his father, Jan, he served in the local militia during the war. They dedicated a sizable portion of the production from their farm to supply the state militia. They also provided or arranged transport for American forces or supplies along the Hudson valley including those destined for the Battle of Saratoga and the Clinton-Sullivan Campaign. Through their considerable personal influence and family ties, they were able to see that locals met the levies of supplies and men necessary to fight the war. (Both images courtesy of Greene County Historical Society.)

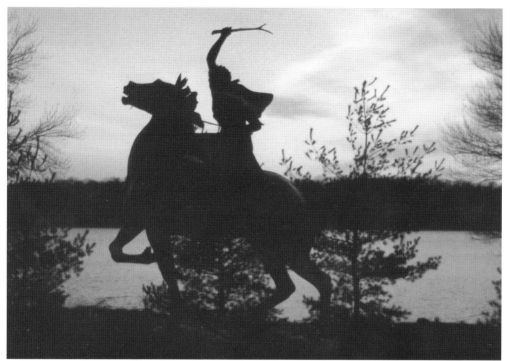

**Sybil Ludington
(April 5, 1761–February 26, 1839)**
On April 26, 1777, Ludington, recognized as the female Paul Revere, rode horseback over 40 miles at night to call out over 400 men from her father's regiment to repel the British at Danbury, Connecticut. They were too late to save Danbury, but later drove the British to their ships—a victory for the colonists. When her husband died in 1799, Ludington applied for and received an innkeeper's license—an occupation at this time held by men. Her tavern was at the corner of Green and Main Streets in Catskill. (Courtesy of V.T. Dacquino.)

Daniel Angle (c. 1753–May 22, 1844)
In the spring of 1776, Daniel Engelcke (Angle) traveled from Germany to Canada to join Burgoyne's army in the American Revolution. Captured at the Battle of Saratoga, he later joined the Continental Army. In 1806, Angle moved to the Town of Lexington, where he became a squatter. Daniel's son Christopher eventually acquired legal title to the land on which his father had squatted and would become one of the leading residents on the mountaintop. (Courtesy of Donna Poulin.)

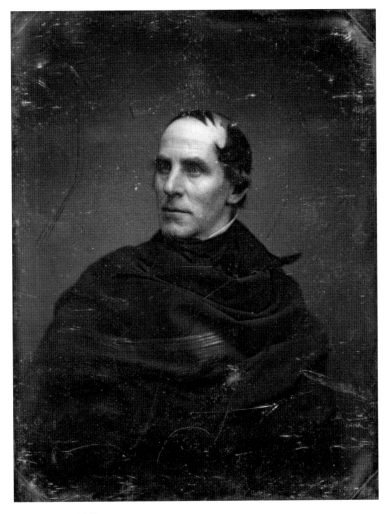

Thomas Cole (1801–1848)

Thomas Cole is recognized as the father of the Hudson River School of Painting. He was born in Northwestern England and immigrated with his family to the United States in 1818. During his early life, he worked primarily as a self-taught itinerant portrait artist, but he did have his paintings exhibited at the Philadelphia Academy's exhibitions. His fame began to grow after an 1825 visit to the Catskill Mountain wilderness and an exhibition of landscapes based on his visit. These came to the attention of prominent figures on the New York City art scene, one being Asher B. Durand. Between 1829 and 1831, Cole traveled extensively in Europe, receiving numerous commissions for his work, increasing his reputation and stature. Shortly after his return to the United States, the artist established a studio in Catskill, New York, when he rented a small outbuilding at Cedar Grove, now the Thomas Cole National Historic Site. It was here that he worked on *The Course of Empire*, a four-canvas masterpiece. Cole married Maria Bartow on November 22, 1836. In March 1839, the artist agreed to produce another four painting series to be known as *The Voyage of Life* for Samuel Ward, a wealthy banker and philanthropist. Beginning in August 1841, Cole made another yearlong trip to Europe, where he traveled and painted. In May 1844, he agreed to accept Frederic E. Church as a student in his studio. Church would become equally as famous as Cole in later years. In February 1846, Cole began another series of paintings to be called *The Cross and the World*. Cole died in the winter of 1848, probably from pneumonia, and is buried in the Thomson Street Cemetery in Catskill. (Courtesy of Library of Congress.)

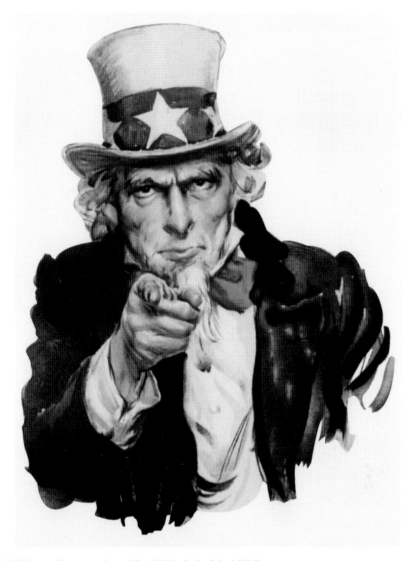

Samuel Wilson (September 13, 1766–July 31, 1854)
Samuel Wilson was a meat-packer from Troy, and—according to an oft-told story—during the War of 1812 he became synonymous with the name "Uncle Sam." As the tale goes, there was a government requirement that meat-packers stamp their names on the barrels of food they were sending to the troops. Besides being a meat-packer, Wilson also worked as an inspector for meat packed by Elbert Anderson. Inspected barrels of meat were stamped "E.A.–U.S.," for Elbert Anderson and the United States. When one of Wilson's workmen was asked the meaning of the letters, he said they stood for Elbert Anderson and Uncle Sam Wilson. Henceforth, the nickname for the United States has been attributed to Sam Wilson. The most iconic image of Uncle Sam appears on a World War I recruitment poster where he is encouraging citizens to join the Army with the words "I WANT YOU FOR U.S. ARMY."

Wilson was born in Arlington, Massachusetts, and at the age of 22 he and his brother Ebeneezer relocated to Troy. There, he and his brother partnered to build several successful businesses. Between 1817 and 1822, Wilson left Troy for a time and ran a meatpacking business in Catskill. Today, the bridge that carries traffic on West Bridge over the Catskill Creek is named in his honor. (Courtesy of Library of Congress.)

Levi Hill (1816–1865)

Hill has been credited by some as the father of color photography. He called his process heliochromy, and the plates he created have commonly become known as hillotypes. During his lifetime, his work was met with skepticism, but chemical analysis conducted over the last 10 years by researchers affiliated with the Smithsonian's National Museum of American History and others has tended to show that his process did have a crude ability to produce color photography. Hill was originally a Baptist Minister in West Kill, but he turned to daguerreotype (early photography) when throat trouble made preaching impossible. (Courtesy of Donna Poulin.)

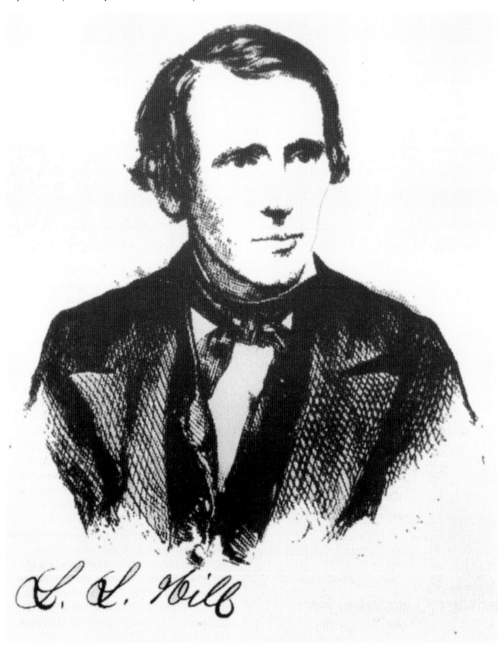

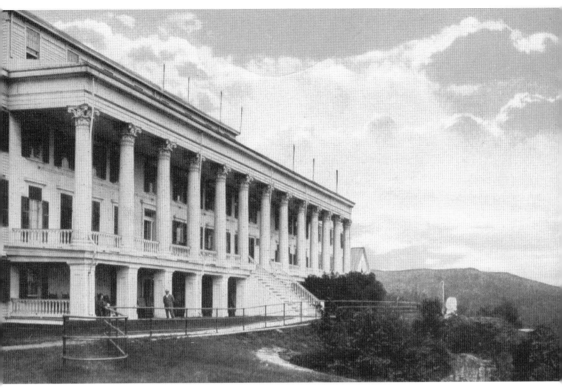

Charles L. Beach (1808–1902)

Beach is remembered for his ownership of the first great mountaintop hotel, the Catskill Mountain House, which was perched on a ledge on the Catskills' South Mountain. In 1823 a group of Catskill businessmen formed the Catskill Mountain Association and built the hotel. In 1845, Beach took full ownership and expanded the hotel. Over the ensuing years, he changed the original Federalist design into the Neoclassical structure that became world-famous and attracted American and European society. Originally, people arrived at the hotel by stagecoach. In 1882, the Beach family was instrumental in building the Catskill Mountain Railroad to transport people from Catskill to Palenville where they boarded the Otis Elevating Railroad to complete their trip. After Beach's death, the hotel continued to be owned by the family until 1932. Eventually, the old structure fell into disrepair and was burned on January 25, 1963. Pictured above is the Catskill Mountain House; at left is Charles L. Beach. (Both images courtesy of Greene County Historical Society.)

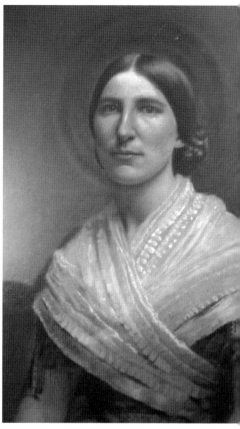

**Eleanor Christina Heermance
(November 24, 1820–February 27, 1907)**
As a young woman, Heermance became well read,
was active in church and community organizations,
and traveled extensively. She never married, and, as
a woman of the Victorian era, her opportunities to
take leadership roles in her community were limited,
but she was very active in the Second Reformed
Church. She served as treasurer for both the Ladies
Aid Society for over a decade and the old Coxsackie
Cemetery on Mansion Street for many years. When
Heermance passed away she left her family home
located at 1 Ely Street, her personal collection of
books and a substantial trust fund to establish a
free circulating library for the people of Coxsackie:
the Heermance Memorial Library—a gift that has
provided enrichment to residents for over a century.
(Courtesy of Heermance Memorial Library.)

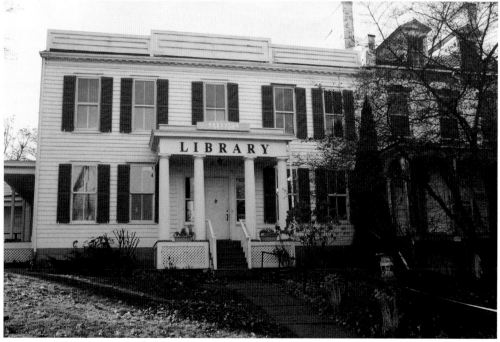

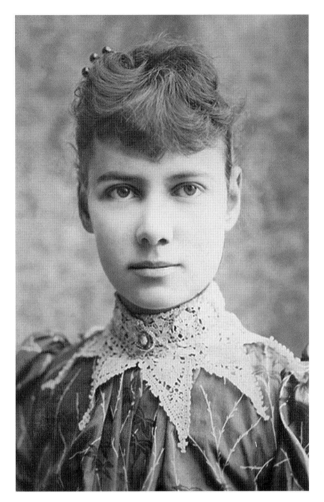

Nellie Bly (May 5, 1864–January 2, 1922)
Nellie Bly was a pen name for Elizabeth Jane Cochrane, a pioneering investigative reporter. She got her start in journalism when she wrote a rebuttal to an article in the *Pittsburgh Dispatch* and later convinced the owner to hire her even though she was a woman. While there, she wrote articles on the plight of female factory workers. She posed as a female operator in a bottling plant to expose the awful conditions under which women worked in factories. Pushed into writing for the women's pages, she volunteered to go to Mexico as a foreign correspondent. Later, Bly moved to New York City where she obtained a job at Pulitzer's *New York World*. While there, she decided to go undercover and do a report on the Women's Lunatic Asylum on Roosevelt Island (Blackwell Island). Her report made her famous. After a grand jury investigation of the asylum, funds were increased for the care of the inmates, and more thorough examinations were required. While at the *World*, she also was assigned to take a trip around the world attempting to turn the fictional *Around the World in Eighty Days* into a fact. Bly made it in 72 days.

In 1895, Bly married Robert Seamans of Catskill and lived in his home on Prospect Avenue where St. Joseph's Villa now stands. She retired from writing and became president of the Iron Clad Manufacturing Co., a gift from her husband. For a time, she was one of the leading female industrialists in the United States. The company later went bankrupt. With her husband deceased, Bly went back to reporting. Her most noted stories were on Europe's Eastern Front during World War I and the Women's Suffrage Parade of 1913. She died of pneumonia in New York City at age 57. (Courtesy of Library of Congress.)

Candace Thurber Wheeler
(March 24, 1827–August 15, 1923)
Wheeler became the leading American textile designer of the late 19th century. In 1883, she, her husband, her brother, and his wife bought land in Greene County and began Onteora, an artistic summer colony. Her cottage, Pennyroyal, became the first of many. This private summer community still includes a few of the original cottages and other buildings, some of which were designed by Wheeler. (Courtesy of Library of Congress.)

Jessie Van Vechten Vedder
(September 29, 1859–March 3, 1952)
Vedder was named the first Greene County historian in 1922. In 1926, she helped to organize the On-Ti-Ora Chapter of the Daughters of the American Revolution and was one of the organizers of the Greene County Historical Society. Vedder also published a long list of works consisting of articles, booklets, and bound volumes. She is fondly remembered for being instrumental in saving the well-known Leeds arched stone bridge. (Courtesy of Greene County Historical Society.)

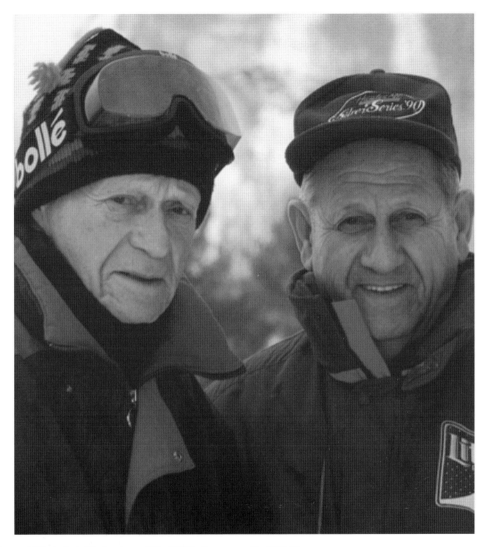

**Israel Slutzky (February 25, 1913–January 5, 2006)
and Orville Slutzky (February 13, 1917–April 18, 2013)**

Israel and Orville Slutzky grew up on their parents' farm in Jewett. In 1939, they founded the construction firm of I. & O.A. Slutzky. The firm worked on large construction projects in Greene County and other places in New York State, building roads, bridges, restaurants, schools, hospitals, drive-in theaters, shopping centers, and motels. Their real fame came in 1962 when they took over ownership of the ski slopes they had built and what would become known as Hunter Mountain Ski Bowl. It would become one of the premiere skiing venues in the Northeast. The Slutzkys were also early pioneers in the art of snowmaking. In 1980, when the winter Olympics were held in Lake Placid, the games were jeopardized because of the lack of snow. The Slutskys' snowmaking equipment was moved to the site and helped solve the problem. Over the years, the brothers helped to transform the Hunter Mountain Ski bowl into a four-season destination with international music, cultural events and the recent addition of a zip-line tour. The success of their operations has brought about an economic renaissance on the south side of the mountaintop in Greene County and many other businesses spun off or started because of it. The Slutzky brothers were also known for their philanthropy, contributing to many community projects and helping countless people, often anonymously. (Courtesy of *Columbia-Greene Media*.)

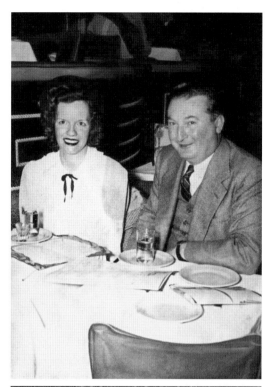

Joe and Kate Konopka, Red's Restaurant

Joe and Kate Konopka are the fourth owners of the iconic Red's Restaurant in Coxsackie. Red's was founded in 1944 by Red Mays, and by 1952, he had expanded the dining area six times its original size and the kitchen 20 times its original size. Red attributed his success and rapid expansion to his shrimp cocktail, which prompted people to refer to Red's as "The House that Shrimp Built." Hans and Freda Bartels purchased the restaurant from Red Mays in the mid-1950s, and in 1971, it was purchased again by Ed Barber and his wife, Cathy. In 1999, Joe and Kate Konopka purchased the restaurant and have run it for the last 15 years. They have instituted many innovations and improvements, and the restaurant continues to be one of the most popular and longest lasting eating establishments in Greene County. Pictured above are Red and Sue Mays. Pictured below are Joe and Kate Konopka. (Courtesy of Joe and Kate Konopka.)

CHAPTER TWO

Educators, Historians, and Writers

Education has always been an important cornerstone of a free society. Greene County is no different than other places in the state in its desire to educate its young people. By 1850, statistics of our schools showed 176 public schools with 177 teachers and 8,216 students. There were also 12 academies and other schools with 14 teachers and 325 students. By the middle of the next century, those public school numbers had been reduced to six as large centralized public schools became the norm. In this chapter the authors have tried to touch on a few of the educators who made a difference in young people's lives.

Preserving local history is important as well. Greene County has produced many people who worked diligently to preserve the area's heritage and educate the public about the history of the county. Jessie Van Vechten Vedder, the first Greene County historian, was instrumental in saving the historic Leeds Stone Bridge. Her successor, Mabel Parker Smith, discovered and saved the priceless Van Bergen Overmantel and worked to put Flint Mine Hill on the National Register of Historic Places. She was followed by Raymond Beecher, who wrote several books on Greene County and was instrumental in saving Cedar Grove, Thomas Cole's home. In addition, many town and village historians have worked tirelessly to ensure that history is preserved.

Writers who have called Greene County home range from the drama critic Brooks Atkinson to novelist Jane Barry and local newspaper columnists Bob Beyfuss, Dick Brooks, Dick Nelson, and Bob and Joanna Titus. Not to be forgotten are diarist Elizabeth Miller, restaurant critic and cookbook author Patsy Bruno, cartoonist Scott Adams, and book publisher Debbie Allen. These people have added to locals' knowledge and helped to give Greene County a greater appreciation and understanding of the world.

Mary Mapes Dodge (January 16, 1831–August 21, 1905)

Dodge was born in New York City to an academic family. She was married at age 20 and had two sons. When her husband died seven years later, she started writing to support her family. She started working with her father and then became associate editor for *Hearth and Home* magazine alongside Harriet Beecher Stowe. She was the first editor of *St. Nicholas: Scribner's Illustrated Magazine for Girls and Boys* from its beginning in 1873 until 1905. It was considered the finest American children's magazine of the 19th century. She is most well known for her book *Hans Brinker* or *Silver Skates*. She died at her summer cottage in Onteora Park in Tannersville. (Courtesy of Library of Congress.)

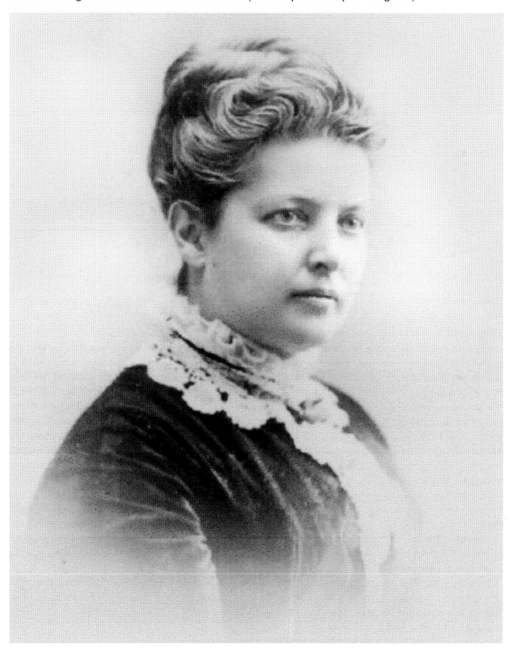

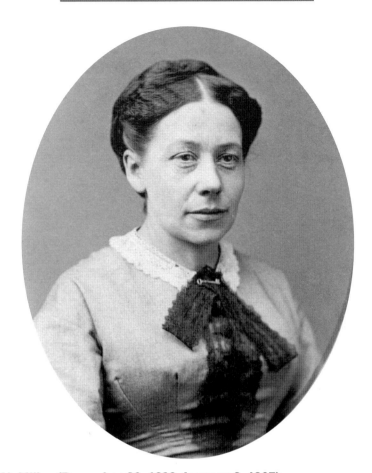

Elizabeth H. Miller (December 30, 1829–January 8, 1907)

Miller was born and lived in the Town of New Baltimore. It is not that Miller's life was so unique, but rather that starting at the age of 31, she kept diaries, which were remarkable for their descriptions of day-to-day life and struggles during a time of national concerns. One of the most touching personal entries was in April 1861, when Miller wrote, "Abigail and I helped Lydia put away the children's clothes." It sounds so innocent, but Lydia's children, ages 13, 5, and 2, had died of diphtheria the previous autumn. Her diary entries talk about such things as doing a mountain of baking, carpets being taken up and beaten and then tacked down again, refilling straw mattresses, repainting bare floors, papering and painting the privy, and taking care of ill family and friends. She wrote, "Cleaning house is bad enough but company and cleaning house is unendurable." She also made entries about the Civil War. She wrote about the attack on Fort Sumter, Lincoln's replacement of his ineffective generals, the New York City draft riots, and of Lee's surrender to Grant. Miller, her sister, and brother took a train to Albany to see Lincoln's funeral procession. She wrote, "That midnight procession I shall never forget. The deep night lighted only by lines of torches on either side, the white horses with slow measured step drawing the precious burden, the dark pall bearers, the solemn dirges, the minute guns. . . . We went in the chamber at half past 2; I have never felt the deep damnation of the blow that felled him as when looking on his calm, placid, peaceful face."

Later in life, Miller moved to Newburgh to work in the editorial offices of the *Household Magazine*. She moved on from there to New York City to be the manager of the offices of the *Illustrated Christian Weekly*. She also wrote many articles for the weekly. In March 1877, Miller married Warren Hathaway, a pastor with four children. Miller passed away at age 77. Over 300 people attended her funeral. (Courtesy of Greene County Historical Society.)

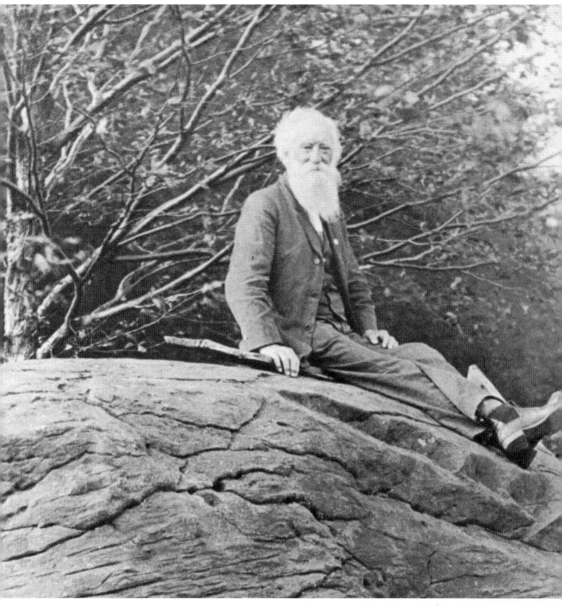

John Burroughs (April 3, 1837–March 29, 1921)
Between 1871 and his death in 1921, Burroughs is credited with writing a book every two years plus countless essays which were published in popular magazines of the time. At the age of 17, Burroughs was in the first class to attend the Ashland Collegiate Institute and Musical Academy, at that time called the Hedding Literary Institute. Even at this early age, Burroughs seemed to excel in writing. There were 200 boys and girls his age at the school, and he says, "I remember I stood fairly high in composition—only one boy in the school ahead of me." Ashland's long-gone Hedding Literary Institute can lay claim to providing some of the fundamentals that led to John Burroughs becoming one of the most popular writers on nature of his day. (Courtesy of Greene County Historical Society.)

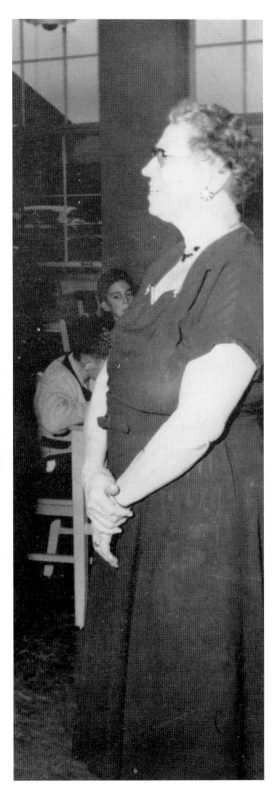

Alice "Ma" Robbins (January 17, 1891– November 24, 1970)

Robbins was a well-known teacher in Coxsackie. She started teaching in the one-room school house in Climax in 1909 and continued in the local district as it evolved over the next 50 years. She was known as "Ma" Robbins to her students, but she was always addressed as Mrs. Robbins to her face. Perhaps one reason she was known as "Ma" was because, as well as being a classroom teacher, Robbins took charge of the lunchroom. The date she started her kitchen detail is not certain, but she was featured in *Look* magazine in 1945 for her work in supervising the Coxsackie School cafeteria. The image in the *Look* article is of Robbins standing next to what looks like a woodstove with a caption indicating that last year she had canned 500 jars of fruits and vegetables in her home for later use in the school's luncheons where an average of 460 students a day were served lunch. Robbins arrived at school early every day to help prepare the day's meals. Between classroom breaks, she would check on the progress of the preparations in the kitchen, and after school she would work on the menu for the next day. The students paid 15¢ for their lunches, 9¢ of which was subsidized by the United States Department of Agriculture. Lunch always included meat or fish, potatoes, a vegetable, and milk in a glass recyclable bottle. If students desired a sweet, they could purchase a homemade dessert—a cupcake for 3¢ or cake and fruit for a nickel. If students wanted something rather than the main entrée, then they could purchase soup for 5¢ and a sandwich for 5¢ or 10¢, depending on the filling. Before her retirement in 1960, she was a junior high math teacher and her services in the cafeteria were no longer needed. She had touched the lives of hundreds of students and impacted the community greatly the community as well. In 2012, she was one of six recipients inducted into the inaugural Wall of Honor at Coxsackie-Athens Central School, which honors the accomplishments of outstanding former students and staff. (Courtesy of Coxsackie-Athens Central School.)

Elizabeth Morrison Boice (December 20, 1903–May 28, 2001)

Boice grew up at 14 Spring Street in Catskill. Her career with the *Catskill Daily Mail* started as a teenager working part-time while attending Katharine Gibbs School in New York City. She started work there full-time upon her graduation. In 1932, Boice founded the Fortnightly Club of Catskill and served as its first president. She started her own daily column in 1939 titled, "About the Town and County with Betsy," which was filled with hometown news. On January 18, 1997, the Catskill Community presented her the Local Hero Award, and in 1998 she was named Woman of the Year at the 65th anniversary celebration luncheon of the Fortnightly Club. Her career at the *Daily Mail* spanned the ownership of five different publishers and lasted a remarkable 71 years. Pictured on the left is Betty Boice with her sister Honor Moore. (Courtesy of Tracey and Roger Moore.)

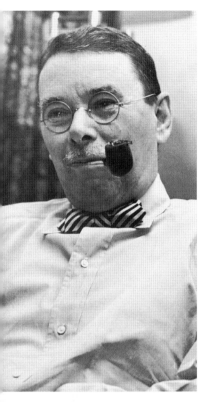 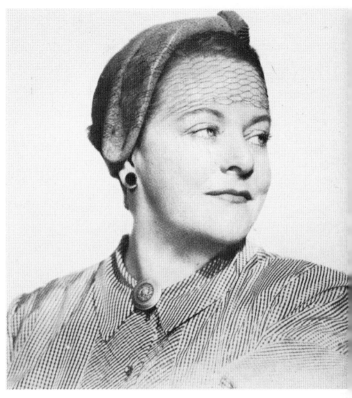

Brooks Atkinson (November 28, 1894–January 14, 1984) and Oriana Atkinson (c. 1895–July 31, 1989)

Drama critic for the *New York Times* for over 30 years and then its critic at large, Brooks was sent to Moscow following World War II. As foreign correspondent of *The Times*, he won the Pulitzer Prize in 1947. He was elected a fellow of the American Academy of Arts and Sciences in 1960 and served as a member of the board of trustees of the Durham Center Museum. Oriana was the author of numerous books, two of which were best sellers. One, *Over at Uncle Joe's,* published in 1947, was a personal account of her life in Russia with her husband. Several of Oriana's novels, such as *Big Eyes* and *The Golden Season,* were set in Greene County. She also wrote *Not Only Ours*, which is the history of their house on Prink Hill in Durham. (Courtesy of Library of Congress.)

**Vernon Haskins
(September 25, 1904–
May 1, 1985)**
Haskins started the Durham
Center Museum in the 1940s
when he bought an old school
house for $55 on Route 145 in the
town of Durham. He was looking
for a place to house his growing
personal collection of Greene
County artifacts and other items
of curiosity. The museum is
located along the road that once
was the historic Susquehanna
Turnpike and not far from where
the first railroad in Greene
County ran. (Courtesy of Durham
Center Museum.)

**Charles E. Dornbusch
(November 17, 1907–April 19, 1990)**
In a simple ceremony on May 17, 1964,
the Jessie Van Vechten Vedder Research
Library in Coxsackie was dedicated, with
Dornbusch appointed as its first librarian.
In addition to being a trained librarian,
Dornbusch ran Hope Farm Press &
Bookshop in Cornwallville, which he left
to the Greene County Historical Society
upon his death. The proceeds from the sale
of the business provide continuing financial
support for the library. (Courtesy of
Greene County Historical Society.)

Mabel Parker Smith (March 1, 1902– February 26, 1996)

Smith was Greene County historian from 1961 until 1992. She was born in Maryland and grew up in Syracuse. She and her twin sister, Mildred, were the first registrants in the four-year journalism class at Syracuse University, and together they made up half the graduating class in that major in 1923. She initially took a job as city editor for the *Catskill Daily Mail* and then moved on to work for the *Syracuse Post-Standard*. She returned to Catskill in 1925 when she married attorney Lester R. Smith. In the 1930s and 1940s, she worked for the *Middletown Times Herald*, covering special issues from Albany. For many years, she was the only woman in the press room at the New York State Capitol who had her own desk and typewriter. As she spent more time in her new home in Catskill, she became increasingly interested in the history of Greene County. She did pioneer research interviewing stagecoach drivers, hiking the trails and interviewing the owners of landmarks in order to document the historical importance of the Catskill Mountain House. Smith is credited with recognizing and saving the Van Bergen Overmantel, a primitive painting that is perhaps the oldest and only visual record of everyday 18th-century Dutch life in the Hudson Valley. In addition to several publications, she produced while Greene County historian, she also wrote the popular *A History of Greene County*. She could be considered an early feminist celebrating the virtues of many Greene County women of the past in her column she wrote for the *Catskill Daily Mail*. She was a charter member of the Greene County Historical Society and started the society's annual lecture series, which continues to this day. (Courtesy of Greene County Historical Society.)

Jane Barry (July 25, 1925–September 29, 2001)

Barry, the author of many books, lived in the Hudson Valley all her life. In 1946, she embarked on a writing career. She worked on both the Coxsackie *Union News* and the Greene County *Examiner Recorder*. She wrote and edited a 52-page centennial edition of the former paper, which won the New York Publishers Association prize for the best single issue of a weekly newspaper published in the state in 1951. Barry's first of six books, *The Long March*, was published in 1955. Over the years, she also became an avid gardener, accomplished botanist, and enthusiastic bird-watcher. Barry's sixth book, *Grass Roots*, although historical fiction, was based on a political campaign by Hamilton Fish Jr., whose campaign was managed by her husband's firm, John Barry Associates. (Courtesy of Doubleday & Company, Inc.)

Elwood Hitchcock (March 22, 1908–January 10, 2004)
Born in Big Hollow (now Maplecrest), Hitchcock attended a one-room schoolhouse before attending and graduating from Windham High School. Interestingly, his career in education began with teaching in one-room schoolhouses in East Jewett and Maplecrest. In 1948, he became district superintendent in Greene County, and in 1967, the State Education Department enlarged his district to include over 20 schools in Greene and surrounding counties. Hitchcock retired in 1971 after devoting more than 40 years to education. During his lifetime, he made many community contributions including serving as historian of the Town of Jewett for 25 years. With his wife, Alvena, he authored three books on local history on the mountaintop. He also wrote the East Jewett column for the *Windham Journal* and the *Daily Mail* for 35 years. (Courtesy of Alvena Hitchcock.)

Raymond Beecher (March 8, 1917–October 9, 2008)
Born in New York City, Beecher grew up in Greenville and went on to become the Greene County historian for 15 years, until his death in 2008. A World War II veteran, he was very active in veterans programs throughout his life. He also served as Coxsackie town historian for many years. His entire adult life was dedicated to public service. Over the years, he worked as a volunteer in several positions for the Greene County Historical Society, including curator, librarian, president, and chairman of the board. He also led the effort through his time and financial support to build a new state-of-the-art research library on the grounds of Greene County Historical Society headquarters in Coxsackie. The facility was dedicated in 1996. Beecher served as the editor of the society's popular quarterly history journal for over a decade. In addition, he authored several books on Greene County history. Some of the titles are *Out to Greenville and Beyond*, *Under Three Flags*, and his last and best-known *Kaaterskill Clove: Where Nature Met Art*. Perhaps his proudest and most long-lasting achievement occurred in 1998 when he was a driving force behind saving Cedar Grove, the Thomas Cole House—a national historic landmark. Beecher not only gave generously toward the purchase of the site, but upon his death he made a sizable bequest in his and his wife Catherine's name for the maintenance of the property. (Courtesy of Greene County Historical Society.)

Dr. Olga Santora (December 17, 1915–May 23, 2010) Santora, who held a doctorate, retired as a full professor from SUNY New Paltz in 1985. She started the master's program in reading there and was the first director of the program. Santora was an active member of many local organizations and held the position of president in several. Upon her death, she left endowments to county historical societies in Greene and Delaware Counties, SUNY Oneonta, and New Paltz. She will long be remembered for her commitment to education and for her philanthropy. (Courtesy of Coxsackie-Athens Central School.)

Franklin B. Clark (October 15, 1911–August 17, 2012) In 1948, after a career of increasing responsibilities in the field of education, Clark was appointed district superintendent of schools for the First Supervisory District of Greene County. As district superintendent, he helped guide deliberations for the siting of the first high school for the new Coxsackie-Athens School District. He also helped draft the law authorizing Boards of Cooperative Educational Services, now Questar. (Courtesy of Coxsackie-Athens Central School.)

Robert G. Chaloner (August 28, 1899–November 6, 1952) and Robert G Chaloner Jr. (March 8, 1934–February 27, 2009)
Robert G. Chaloner was a principal for 25 years and was one of the driving forces behind the centralization of Coxsackie and Athens Union Free Districts as well as selecting the site where the school is located today. The school athletic field is named in his honor. Chaloner was a founder of the Coxsackie-Athens Rotary Club and involved in a number of civic organizations. His son Dr. Robert G. Chaloner Jr. was also involved with the school district. Dr. Chaloner served a dual role of Coxsackie-Athens Board of Education president—a role he served for over 20 years—and school physician. Both father and son believed in public education and demonstrated a true passion for making it better. (Courtesy of Margaret Chaloner.)

Pasquale N. Bruno Jr. (January 8, 1933–October 30, 2012)
Bruno was born and raised in Athens. In 1978, he opened a chain of stores in the Chicago area called Cook's Mart, which sold gourmet cookware and household items. He also invented the first pizza stone for home use in the early 1970s as well as 25 different kitchenware tools. He authored five books on pizza and pasta making and was the owner of the cooking school Cucina Paradiso in Chicago. As a restaurant critic, Bruno wrote a weekly review for 27 years for the *Sun-Times* and was a contributing writer for *Pizza Today* magazine for 20 years. The magazine named their Pizza-Maker of the Year Award the Pasquale "Pat" Bruno Pizza Maker of the Year Award. Shortly before his death, Bruno was quoted as saying, "There is no stress in the presence of a pizza." (Courtesy of Donald Link.)

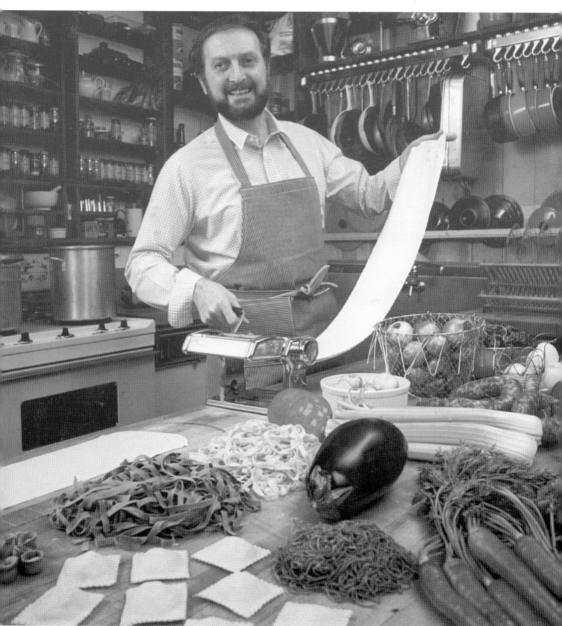

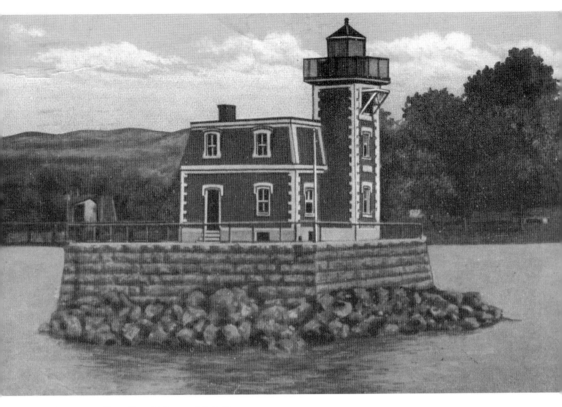

Brunner Family, Athens Lighthouse
Visitors who make the trip by boat to the Hudson-Athens Lighthouse are often greeted by Emily Brunner, who lived on the lighthouse with her family in the 1930s and 1940s and relates stories about the life in a lighthouse. The lighthouse had four bedrooms, a good-sized kitchen, and a family room. "But we had an outhouse that hung out over the river," she recalls. When the Brunners arrived, there were three children: Emily, the oldest; Richard; and John. Two more children followed: Robert, who was born in the lighthouse; and Norman, who was born in the Catskill Hospital. Their father, Emil Brunner, was the last light keeper. Eventually, the operation was converted from light produced by kerosene flame and manual mechanical operation to electricity, and there was no longer a need for a full-time lighthouse keeper. (Courtesy of Greene County Historical Society.)

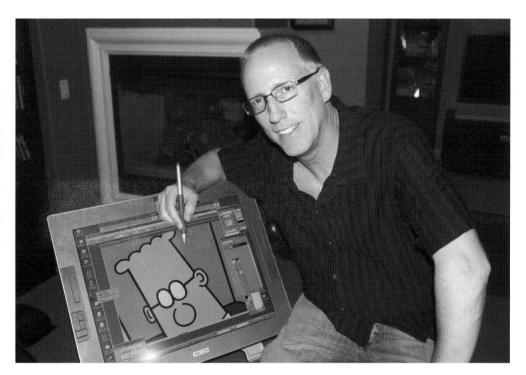

Scott Raymond Adams

Adams graduated as valedictorian in 1975 from Windham-Ashland-Jewett Central School. After college graduation, he moved to California and worked for Crocker National Bank between 1979 and 1986 and Pacific Bell from 1986 until 1995. While working at Crocker, he created the cartoon *Dilbert*. Personalities and situations he encountered while working became the inspirations for many of his cartoons. The cartoon took off slowly, but by 1994, it was in 400 newspapers. In 1996, Adam's first business book, *The Dilbert Principle*, was released. In 1997, he won the National Cartoonists Society's Reuben Award for Outstanding Cartoonist of the Year and Best Newspaper Comic Strip. The next year, there was even a television series called *Dilbert*. By 2000, the *Dilbert* comic strip was appearing in 2,000 newspapers in 57 countries and 19 languages. (Courtesy of Scott Adams.)

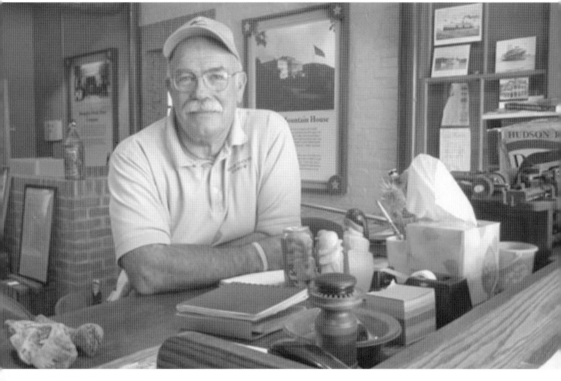

Richard "Dick" Brooks

A longtime contributor for the newspapers of *Columbia-Greene Media* and winner of three New York Press Association awards, Brooks is well known for his humorous column "Whittling Away." Like Andy Rooney of CBS fame, he finds humor in life's mysteries and incongruences. Brooks can find something amusing in almost everything, from his weekly trip to the grocery store to trying to produce a crop of tomatoes. (Courtesy of *Columbia-Greene Media*.)

Robert "Bob" Beyfuss

Beyfuss is the author of numerous publications regarding ginseng, organic gardening, and mushroom growing in forested areas, with titles such as *American Ginseng Production in NY State*, *The Economics of Woodland Ginseng Production*, and *Growing Gourmet Mushrooms from A to Z*. Beyfuss has also authored a weekly gardening column in local newspapers for more than 30 years, and his weekly radio spots have aired continuously for 35 years. (Courtesy of Robert Beyfuss.)

Justine Hommel

For most of her adult life, Hommel has served her community tirelessly as keeper of historical facts and preserver of the rich history of her beloved mountaintop in Greene County. She worked for Haines Falls Free Library from 1950 to 1997. In 1950, she started driving the Haines Falls Free Library Bookmobile to outlying areas to connect the people there to books and other services the library had to offer and worked for the library on other days. In 1959, she became the librarian. She was a founding member of the Mountain Top Historical Society and served as its president off and on for 35 years. She was instrumental in the acquisition and restoration of the Ulster and Delaware train station, which serves as the historical society's visitors center. Justine served as Hunter town historian from 1982 until 2012. In 2011, Hommel was the recipient of the Greene County Historical Society's first Jessie Van Vechten Vedder Award. The award honored her for her lifelong contribution to preserving, interpreting, and promoting the area's history. In 2012, when the Mountain Top Historical Society dedicated its archival room, it was named the Justine Legg Hommel Archive Room in honor of Justine's dedication, commitment, and service. At her official retirement party as Hunter town historian, she was given a commendation from the Greene County Legislature for her dedicated service to her beloved mountaintop. It is always a pleasure to visit Justine at her home, where she will regale you with stories of the mountaintop. Hommel is a Greene County treasure. (Courtesy of Greene County Historical Society.)

Hudson Talbott

Talbott has written and illustrated over 20 books for young readers. His books have been made into films, musicals, and have won several awards, including the Newbery Honor. After living and studying abroad for several years, Talbott began a career in New York City as a freelance designer and illustrator commissioned by the Metropolitan Museum, the Metropolitan Opera, Bloomingdale's, and the Museum of Modern Art, among others. While with the Museum of Modern Art, he created his first children's book called *How to Show Grown-ups the Museum*. His next book, *We're Back! A Dinosaur's Story*, was produced as a feature-length animated film by Steven Spielberg, who also bought the film and television rights to other books that followed. Talbott also collaborated with the composer Steven Sondheim on a book adaptation of the composer's musical *Into the Woods*. Two other books, *River of Dreams* and *O'Sullivan Stew*, have since been adapted and produced for the stage as children's musicals.

Talbott's lifelong impulse to travel has informed the subject matter of several books. *Amazon Diary* came after his trip to the Amazon rainforest, where he journeyed with a jungle doctor who brought malaria medicine to remote indigenous tribes. *Safari Journal* was the product of his travels with a wildlife veterinarian in Kenya. Currently, he is working with an orphanage in Laos to develop programs for teaching English and art to the children living there. His last book was inspired by his two cats and is called *It's All About the Me-ow*. Talbott splits his time between his loft in Manhattan and his farmhouse in Greene County. (Courtesy of Hudson Talbott.)

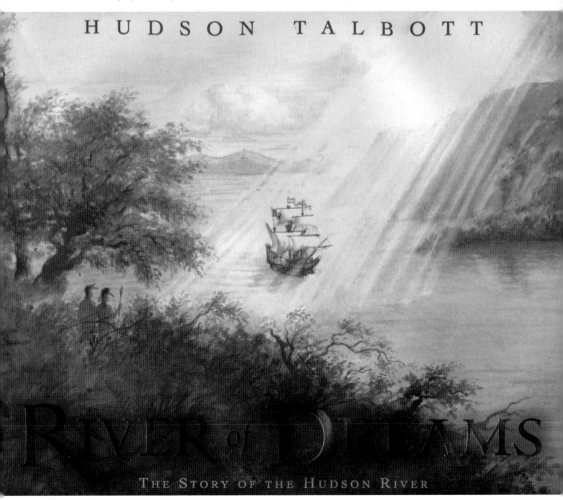

HUDSON TALBOTT

RIVER of DREAMS

THE STORY OF THE HUDSON RIVER

Robert and Johanna Titus

The Tituses are both professors, he at Hartwick College in Oneonta and she at SUNY Dutchess in Poughkeepsie. Both are trained scientists with advanced degrees. Robert, a paleontologist, has published numerous articles on upstate New York paleontology in scientific journals. Johanna, a biologist, has a background in fresh water ecology and has been active in that field. They have, as a common goal, a desire to engage the public in the natural history of the Catskills and Hudson Valley through understandable popular science writing. They write regular articles in *Kaatskill Life* magazine, weekly columns for the newspapers of *Columbia-Greene Media*, and frequent articles in the *Woodstock Times*. Robert has written three books about the geology of the Catskills. Most recently, the two wrote the book *The Hudson Valley in the Ice Age*. They also give lectures about the geological history of the area. (Courtesy of Robert and Johanna Titus.)

Charles Swain (December 5, 1940–December 22, 2013)

Swain was born in Catskill and was appointed the county's first minorities historian in 1975. He is believed to be the first person to hold such a position in New York State. In 1978, he organized a Black Culture Festival. Part of that effort involved gathering and documenting the history and contributions of blacks in Greene County. Swain also spent considerable time documenting the accomplishments of African Americans who served in the Civil War. In 1999, he organized a two-day Civil War Memorial Service in Coxsackie honoring them. Swain was an authority on the Buffalo Soldier and, with his horse, reenacted the role of one at many events. One year during his tenure, he also organized an all-black rodeo in Cairo and raised thousands of dollars for predominately black churches in Coxsackie and Catskill. (Courtesy of Charles Swain.)

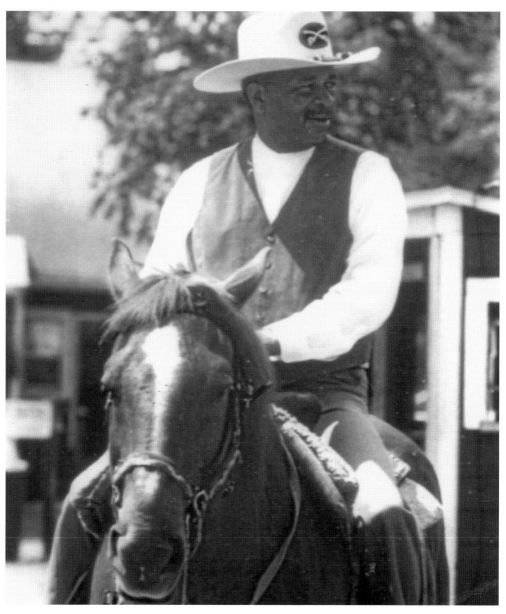

Deborah "Debbie" Allen

Allen is the cofounder of Black Dome Press, a leading independent publisher of New York State histories and guidebooks with a special focus on Greene County, the Catskills, Adirondacks, Capital District, and Hudson River Valley. Founded in 1990 in Hensonville, Black Dome produced about 70 nonfiction titles during Allen's tenure as publisher, including at least 16 focusing on Greene County. Allen's honors include the first-ever Barnes & Noble Focus on New York Award for Outstanding Regional Literature, the Columbia County Historical Society Preservation Heritage Award, the Community of Windham Foundation's Leadership in Cultural Heritage Award, the Distinguished Service Award by the Greene County Council on the Arts, and the Greene Diamond Award from Greene County for contributions to the New York State economy. Black Dome Press continues successfully in the capable hands of longtime editor Steve Hoare. (Courtesy of Deborah Allen.)

Dick Nelson

While born and raised in Brooklyn, New York, outdoor journalist Nelson spent much of his family vacation and outdoor fun time (hunting and fishing) in Greene County. With no formal training in journalism, his writing career began with the *Garden Spot News*—a now defunct Brooklyn weekly newspaper. His column later appeared in the *Greenpoint Gazette*.

Nelson moved to Greene County in 1970 and quickly noticed that the local paper lacked an outdoor column. He approached the managing editor about doing one. His thrice-weekly (now twice-weekly) column has appeared in the newspaper for 42 years, and for several years he was also the newspaper's golf columnist. Between 1988 and 2000, he was the outdoor columnist for the *Albany Times Union*, where he wrote three columns a week and a full page on Sunday. As one of the region's most respected outdoor columnists, Nelson has earned the reputation for providing area sportsmen and sportswomen with timely information on outdoor events and issues—regardless of how controversial the subject—and has been recognized for those efforts by several state and county organizations.

A member of the Outdoor Writers Association of America since 1977, he has been a longtime member and president of both the New York State Outdoor Writers Association and the New York Metropolitan Outdoor Press Association. He is the current publicist for the Ruffed Grouse Society and has been the recipient of numerous newspaper and magazine writing awards. (Courtesy of Dick Nelson.)

CHAPTER THREE

Artists, Performers, and Sportsmen

From the mountains to the river valley, Greene County has always been an attraction for a broad spectrum of artists. As early as the 1730s, an oil painting done of Marten Van Bergen's farm in Leeds on a 16.25-inch-high-by-88.75-inch-long piece of cherry wood, attributed to artist John Heaton, conveys more visual information about early Dutch life in Colonial America than any other surviving object of the period. It not only represents a Colonial period Dutch farm but is among the earliest representations of our panoramic Catskill Mountains. In 1825, Thomas Cole also discovered the beauty that is Greene County. Still today, many talented and imaginative artists call Greene County their home. The late Thomas Locker continued the style of the Hudson River School of Art until his death in 2012, and Larry Federman continues to capture the beauty of the county through his photographs of nature.

Performing artists are not new to the county, either. Maude Adams, who had a home in Onteora, is well known for her performance on stage as Peter Pan; and Blossom Dearie was a popular vocalist and pianist. Many people have also enjoyed Tom Winslow, who played and sang with Pete Seeger. Not to be forgotten are flamenco dancers Rubén and Corinne Garcia.

Performers of a different type—sportsmen—have also made names for themselves. New York Yankee Bill Stafford and Seattle Mariner Mickey Brantley grew up and honed their skills here, and Cus D'Amato found the quiet isolation of Greene County a perfect place to train his boxers such as Mike Tyson.

Frederic Church (May 4, 1826–April 7, 1900)
As a young man, Church was an art pupil for two years of Greene County's Thomas Cole, founder of the Hudson River School of Art, and one of only two artists that Cole tutored at his home, Cedar Grove, in Catskill. Church spent much of his later life at his home, Olana, which is perched high on the ridge that overlooks the Hudson River and Greene County. He is recognized as one of the great landscape painters of the 19th century and a central figure in the Hudson River School of Art. Unlike many struggling artists of his day, Church had extraordinary commercial success, and his art made him a wealthy man. (Courtesy of Library of Congress.)

Albertus del Orient Browere (1814–1887)

Browere was the oldest son of and assistant to John Henri Isaac Browere, a well-known sculptor who made plaster "life" masks of such famous people as the Marquis de Lafayette, John Adams, and Thomas Jefferson. He was born in Tarrytown and pursued painting at a young age rather than as a sculptor, possibly because of an injury to his right hand. Mostly self-taught, in 1832, at age 18 he won a medal for "best original oil painting" at the American Institute of the City of New York. Between 1833 and 1848, Browere also exhibited at the American Academy, the Apollo Association, and the American Art Union. In 1841, Browere moved to Catskill, New York, where he lived for the rest of his life, except for two extended trips to California during and after the Gold Rush. In both cases, he did a considerable amount of painting while there, and his landscapes are particularly valued for their historical perspectives on the lives of the early settlers. Browere had a long career and is known today primarily as a Hudson River landscapist and a painter of still-life subjects, as well as a painter of scenes inspired from the writings of Washington Irving and James Fenimore Cooper. Unlike Thomas Cole and some of his contemporaries, Browere never really seemed to make a satisfactory living painting on canvas. Instead, in order to make ends meet, he painted signs that hung on Main Street in the village for many years, decorated objects (such as a fireboard used as a screen to decorate a fireplace during the summer), painted designs to order for wagons and coaches, and even worked for a time as a clerk in a local drugstore. Today, Browere paintings are highly valued. (Courtesy of Fenimore Art Museum.)

Benjamin Bellows Grant Stone (1829–1906)

Stone, known as B.B.G. Stone, was born in January 1829 at Watertown, Massachusetts. He was tall for his generation, standing over six feet. He developed a taste for fine and fashionable clothing and was considered a bit of a dandy. He was apprenticed to a maker of nautical instruments in Boston where he made deliveries and kept the books. In his limited free time, Stone dabbled in art and attended the theater and the opera. In 1851, while in Boston, he enrolled in art classes under Benjamin Champney. In 1853, he moved to New York City and studied under Jasper Cropsey. He moved to Catskill in 1854, and a year later he made the acquaintance of Mary Allen Dubois, whom he later married. In 1856, Stone rented Thomas Cole's studio from Cole's widow and settled in Catskill. His art work was curtailed by service in the Civil War. He served as a lieutenant in Company K of the 1st Massachusetts Heavy Artillery. Stone's last posting was to the Secret Service. He served at President Lincoln's funeral and was close enough to events in Washington to write to his wife on April 27, 1865, of the capture of John Wilkes Booth and David Herold. At the conclusion of hostilities, Stone returned to Mary and his home on Liberty Street in Catskill. His Civil War service had kept him away from his art, and he had some difficulty in making a living. He accepted commissions for any type of artwork that would bring in money. Throughout his life, Stone kept in touch with other artists of the time, including his art teachers from Boston and New York City, as well as Frederic Church, whom he visited often. In the end, Stone left a vast collection of sketches and paintings of Greene County scenery. (Courtesy of Greene County Historical Society.)

Charles Schreyvogel
(January 4, 1861–January 27, 1912)

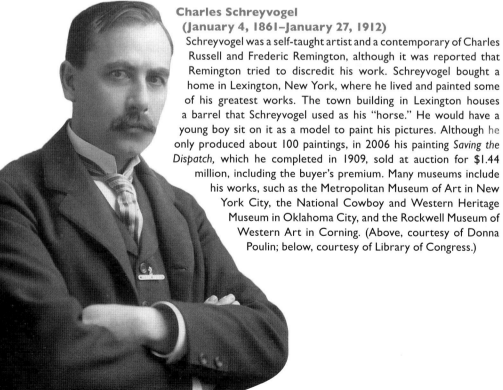

Schreyvogel was a self-taught artist and a contemporary of Charles Russell and Frederic Remington, although it was reported that Remington tried to discredit his work. Schreyvogel bought a home in Lexington, New York, where he lived and painted some of his greatest works. The town building in Lexington houses a barrel that Schreyvogel used as his "horse." He would have a young boy sit on it as a model to paint his pictures. Although he only produced about 100 paintings, in 2006 his painting *Saving the Dispatch,* which he completed in 1909, sold at auction for $1.44 million, including the buyer's premium. Many museums include his works, such as the Metropolitan Museum of Art in New York City, the National Cowboy and Western Heritage Museum in Oklahoma City, and the Rockwell Museum of Western Art in Corning. (Above, courtesy of Donna Poulin; below, courtesy of Library of Congress.)

Ralph Albert Blakelock (October 14, 1847–1919)

Born in New York City, Blakelock was the son of an English-born physician. He attempted to follow in his father's footsteps, but after two years at what is now the City College of New York, he left to pursue his interest in painting. He was self-taught, and his first painting, *View of Mount Washington,* was exhibited at National Academy of Design, New York. He traveled to the White Mountains, the Adirondack Mountains, and the Catskill Mountains and continued exhibiting his landscapes. Between 1869 and 1872, he traveled west and became obsessed with the primeval woodlands, especially at night, and Native American rituals. He sent a few paintings back to family and friends. By 1873, many of his paintings were signed with arrowheads around his signature. He married Cora Rebecca Bailey of Brooklyn in 1875, and they had nine children. Despite his critical success in the art world, he found it difficult to financially support his family. He began to sell his paintings for much less than their known worth. Blakelock suffered his first mental breakdown in 1891. In 1899, he was taken to a state hospital and spent most of the remaining years of his life there. While Blakelock was hospitalized, Cora and the children lived in an impoverished state near the village of Catskill. In 1912, his painting *Moonlight* brought $13,000 at public auction, the highest auction price recorded for a living American artist to that time. In 1916, his painting *Brook by Moonlight* sold at auction for $20,000, again the highest auction price for a living American painter. He was elected full Academician at the National Academy of Design, New York. Not one dollar from the public sales of his pictures came to him. (Courtesy of Greene County Historical Society.)

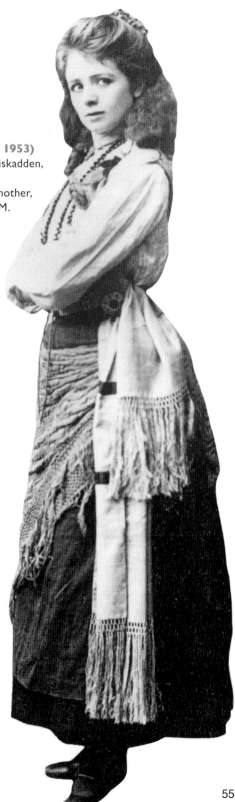

Maude Adams (November 11, 1872–July 17, 1953)
Maude Adams was the stage name of Maude Ewing Kiskadden, who was born in Salt Lake City, Utah. Adams began performing as a child while touring with her actress mother, Annie. She was best known for her performance in J.M. Barrie's *Peter Pan* in 1905, which she performed over 1,500 times in her career. Adams was a stage legend, and her yearly income was greater than $1 million during her peak. In the late 1800s, she purchased land in Onteora Park in Tannersville, New York, and in 1903, built a cottage. From 1937 to 1950, she taught drama at Stephens College in Missouri. She then retired to her home in Onteora. (Courtesy of Library of Congress.)

Art Flick
(August 3, 1904–August 30, 1985)

Flick was a dedicated conservationist and sportsman. He loved the Schoharie Creek in Lexington, where he helped establish the first "Fish for Fun" area in New York State and secured many miles of public fishing rights. It was here that he conducted the research for his classic book *Art Flick's Streamside Guide*, which introduced generations of fly fisherman to the joys of imitating trout stream insects. (Courtesy of Donna Poulin.)

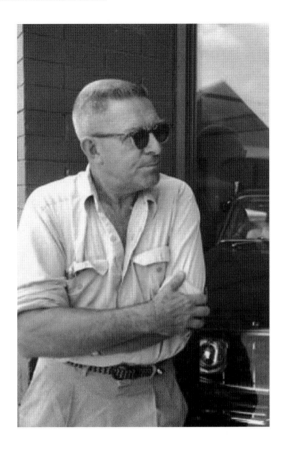

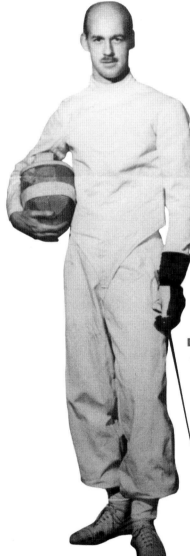

Dernell Every
(August 18, 1906–September 11, 1994)

Born in Athens, Every was a national foil champion and Olympic medalist. Over his career, he was selected as a member of six US Olympic foil teams between 1928 and 1948 and won a bronze medal in 1932. Every was national foil champion in 1938, 1940, and 1945 and was ranked in the top 10 in his fencing specialty for 21 straight years. (Courtesy of Lynn Brunner.)

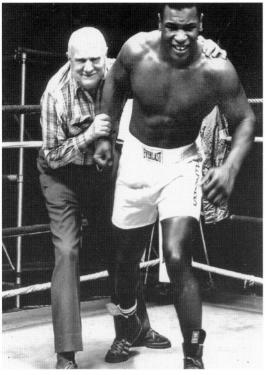

Constantine "Cus" D'Amato (January 17, 1908– November 4, 1985)
Toward the end of his career, D'Amato trained boxers in his gym in Catskill, which is still in use today. It was there he began to work with Mike Tyson, whom he adopted after Tyson's mother died. Sixteen months after D'Amato's death, Tyson won the heavyweight championship, becoming the youngest world heavyweight titleholder in history at age 20. D'Amato is pictured on the left with Mike Tyson. (Courtesy of Fabian P. Garcia.)

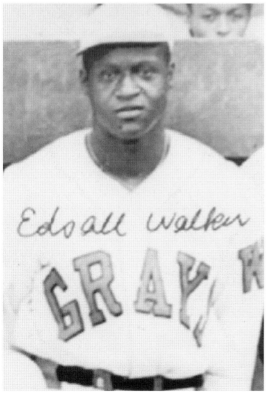

Edsall Elliot Walker (September 15, 1910– February 19, 1997)
Walker was born and raised in Catskill. Starting in 1936, he began to play professionally for the Homestead Grays of the Negro League. One of Walker's happiest memories was outpitching the legendary Satchell Page six to one in a game before 22,000 fans in Washington, DC. His career with the Grays ended in 1945—two years before Jackie Robinson broke the color barrier in the major leagues. (Courtesy of Catskill Mountain Foundation.)

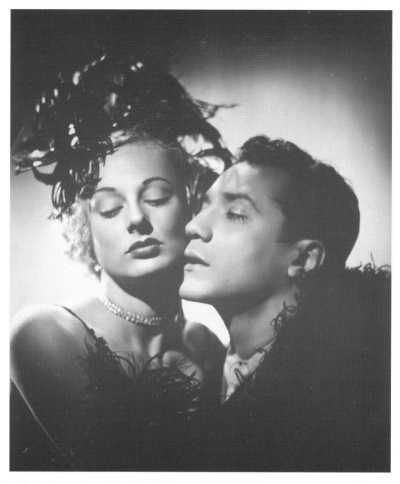

Rubén Garcia (December 28, 1911–August 29, 1994)
Dancer, actor, community organizer, teacher, and historian, Garcia and his wife, Corinne, retired from an active dancing career in 1953. As a couple, they performed flamenco dancing under the stage name of Tito and Corinne Valdez. Both had achieved fame in Europe before touring the nightclub and stage circuit in the United States in the 1930s, 1940s, and 1950s. At their peak, they performed on the *Danny Thomas Show* and the *Ed Sullivan Show*. In 1953, they moved to Greene County, where they had performed several times at local venues. After his dance career ended, Garcia went back to school and became a teacher in the Greenville and Coxsackie-Athens school systems. His love of people and the arts provided the drive for many of his accomplishments after moving here. Perhaps Garcia's most long-lasting accomplishment was his role as a founding member and first chairman of the Greene County Council of the Arts. The council, which still exists today, helps to sponsor established and budding artists and many worthwhile endeavors throughout the county. The Council Garden Party and fundraiser was Garcia's brainchild, and he hosted the party on the grounds of his historic home in Leeds for many years. In 1967, as chair of the Greene County Community Action Committee, he guided the committee to host the first Head Start Program in Coxsackie. He also helped to establish the Catskill Youth Center. As president of the Greene County Historical Society, Garcia directed and produced the bicentennial production for the Town of Coxsackie in 1976, which was presented on the grounds of the historic Bronck House. Upon his death, he bequeathed the priceless Dutch scripture painting *The Transfiguration* to the Greene County Historical Society in memory of his mother, Maria Garcia. Fewer than 50 of these paintings are known to exist in the world. (Courtesy of Francesca Pratten.)

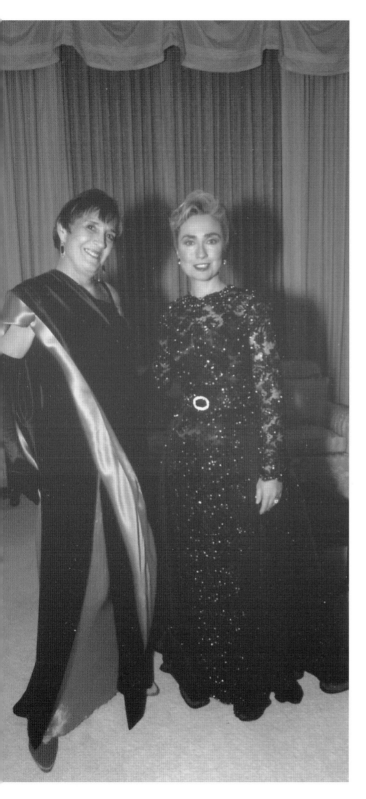

Barbara Matera (July 16, 1929– September 13, 2001) Born in Kent, England, Matera worked in costume design at the Royal Opera House in London during the late 1940s. She moved to the United States in 1960 and founded a shop with her husband in 1968 called Barbara Matera, Ltd., and was a costumer for five decades. She made costumes for over 100 Broadway shows. She also made costumes for films, with some of her more well-known productions being *The Great Gatsby* (1974), *The Addams Family*, *101 Dalmatians*, and *102 Dalmatians*. She also created the purple crystal-encrusted gown that Hillary Rodham Clinton wore to her husband's first presidential inauguration. She had homes in both Manhattan and Athens. Matera sponsored an annual gala at St. Patrick's Church hall that she staged and designed with a different theme each year. The proceeds were donated to the church. (Courtesy of Jared Aswegan.)

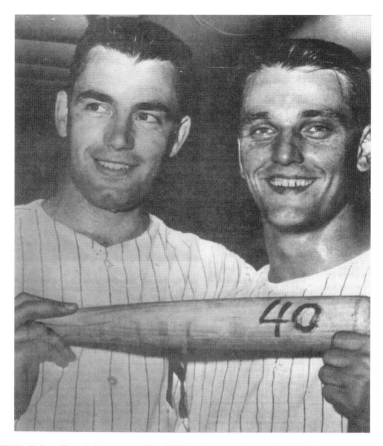

William "Billy" Stafford (August 13, 1939–September 19, 2001)
Stafford was the toast of the little town of Athens from the time he played high school sports until the end of his career with the Kansas City Athletics in 1967. He began his professional baseball career in 1957 playing for the New York Yankee affiliate in St. Petersburg, Florida, and debuted for the big club on August 17, 1960—only four days after his 21st birthday. One of Stafford's finest moments happened on the final day of the 1961 season when he combined with two other Yankee pitchers in a 1-0 win over pitcher Tracy Stallard and the Boston Red Sox. This was the day that Roger Maris broke Babe Ruth's single-season homerun record with his 61st homer of the season in the fourth inning. Stafford started the game, went six scoreless innings, and struck out the first three batters he faced, including future hall-of-famer Carl Yastrzemski. Perhaps his biggest thrill was a complete game in the 1962 World Series. The game was scoreless until the seventh when the Yanks grabbed a three-run lead with the big blow coming on a two-run single by Roger Maris. In the top of the eighth inning with one out, Filipe Alou lined a pitch off Stafford's shin. Stafford recovered the ball in time to get Alou out at first, but he was badly hurt. He said, "The pain made me so dizzy that I started seeing double. I knew the trainer was applying smelling salts and Ralph (Houk, the manager) was standing on the mound. But, I never thought about coming out." Houk said he never considered replacing the young pitcher. He went on to say, "I didn't see any blood on him when I went there." Stafford, who had been sitting on the pitcher's mound, got up after the trainer had sprayed pain killer on his leg and got the third out in the inning. Between innings, Stafford had his leg iced and then went back to the mound to complete the game. He gave up a two-run homer to catcher Ed Baily but hung on to get the 3-2 complete game win. Stafford said after the game, "I couldn't put all my weight on my left leg after Alou hit me, but I never felt I couldn't finish." The Yankees went on to beat the Giants in seven games. Pictured on the left is Billy Stafford with Roger Maris. (Courtesy of Jim Pulice.)

60

Blossom Dearie (April 28, 1924–February 7, 2009)
After spending her childhood in Durham, Dearie began to sing in groups such as the Blue Flames (with the Woody Herman Orchestra) and the Blue Reys (with Alvino Rey's band) before starting a solo singing career. As a vocalist and pianist, she recorded on Verve, Daffodil, Barclay, and Capital/EMI Record labels and had many memorable songs. Dearie also performed regularly at supper clubs during her long career. (Courtesy of Durham Center Museum.)

Thomas Locker (1937–March 9, 2012)
Locker began his career as a landscape painter exhibiting works reminiscent of the Hudson River School of Art. In 1982, he turned to writing and illustrating children's books. His first, *Where the River Begins*, was named one of the 10 best-illustrated children's books of 1984 by *The New York Times*. He went on to illustrate more than 30 works for young people, many of which he also wrote, and garnered numerous additional honors. (Courtesy of Candace Christiansen.)

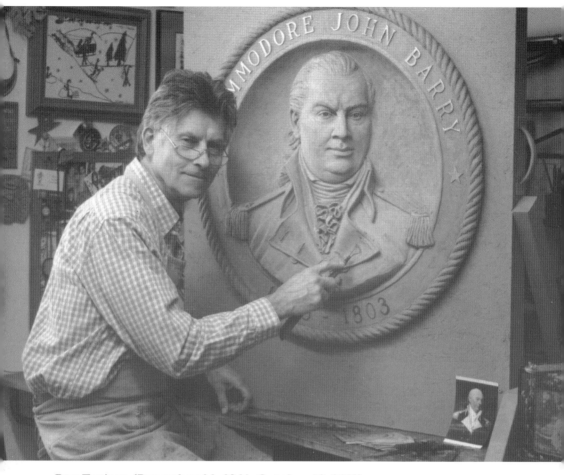

Ron Tunison (December 14, 1946–October 19, 2013)

Tunison pursued his interest in historical figures as early as fifth grade when he sketched, most notably, Davy Crockett at the Alamo and Pickett's Charge at the Battle of Gettysburg—both drawings he proudly displayed in his Cairo studio. In every aspect of his life, he did not waver from his interest in history. He established himself as an expert in the field of Civil War art. Tunison sculpted nine monuments over the course of his short lifetime. Four commissioned heroic bronze monuments stand on the Gettysburg, Pennsylvania National battlefield: *The Friend to Friend*, *The Civil War Women's Memorial of Elizabeth Thorn*, *Gen. Samuel Crawford*, and *The Delaware State Monument*. His *Irish Brigade Monument* is on the Antietam, Maryland National battlefield, and a second bronze casting of the original is at the Museum of General Meagher's home in Ireland. At Dover, Delaware, is Tunison's larger than life-size *Delaware Continentals* atop a 25-foot granite pedestal at Legislative Hall. *Gen. Patrick Cleburne* is at Ringgold Gap in Atlanta, Georgia. *The Bivouac* is at the entrance to the Civil War Museum at Pamplin Historic Park in Petersburg, Virginia. His final monument, a bas-relief of historic *Commodore John Barry* who received the first naval commission from Pres. George Washington was unveiled May 10, 2014, at Annapolis Naval Academy in Maryland. At the time of his death, he was at work on a statue of suffragist Elizabeth Cady Stanton to be installed at Johnstown, New York, in 2015 for the 200th anniversary of her birth. Tunison also established his business Historical Sculptures creating limited edition collectible size statues of his original sculptures of historic figures in hot cast and cold cast bronze, a few of which he hand-painted in oils. Tunison is recognized worldwide for historic accuracy in every detail, exact anatomical proportion, and his unmatched talent for rendering lifelike realistic beauty in clay. (Courtesy of Alice Tunison.)

Steve Hartman

A full-time correspondent on CBS News since 1998, Hartman lives in Catskill. His work appears every Friday on the *CBS Evening News with Scott Pelley* and is titled "On the Road." Hartman reports on unique people and heartwarming stories he encounters in his travels around the country. Before his current series, Hartman was known for another series, "Everybody Has a Story." Debuting in 1998, and continuing for the next seven years, Hartman produced more than 120 such pieces. In 2010, in partnership with NASA, in each "Everybody in the World Has a Story" segment, he reported from random places around the globe selected by an astronaut in the International Space Station. One month, he went around the world twice. Hartman has won numerous awards, including several Emmys. (Courtesy of John Paul Filo/CBS.)

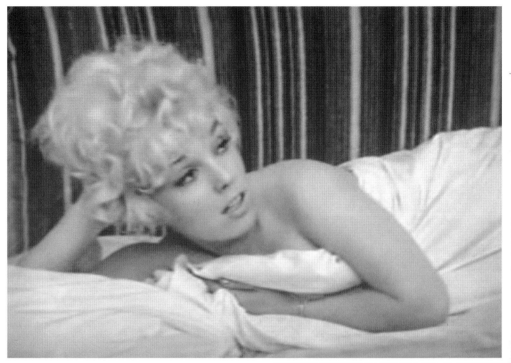

Ulla Darni

Darni is an award-winning, world-renowned artist who creates one-of-a-kind reverse hand-painted "Ulla" lamps. A native of Denmark, she attended the Royal Danish Academy of Fine Arts in Copenhagen and worked at the Royal Copenhagen as a designer and painter of porcelain. She was the winner of a Danish Marilyn Monroe lookalike contest, which led to an acting and singing career. She relocated to the United States with her family and became recognized as a fine artist. She has exhibited nationally and internationally, and her work is on display in galleries and museums around the world. Her signature, "Ulla," and her fingerprint are registered with the Library of Congress. She has a studio in Acra and, like her lamps, Darni is a lovely and priceless addition to Greene County. (Above, courtesy of "Duellen" by Knud Leif Thomsen; right, courtesy of EchoStarmaker.com.)

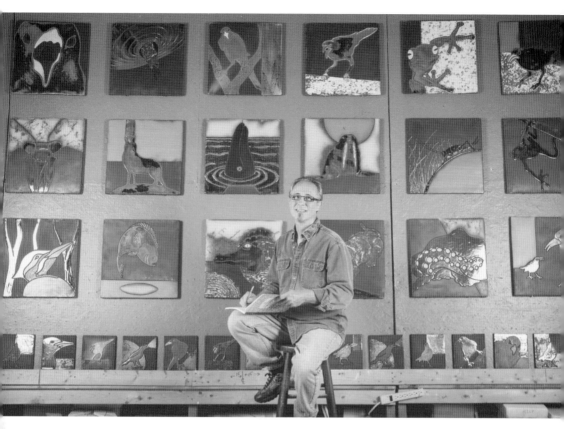

Frank Giorgini

Giorgini is one of the foremost designers and fabricators of handmade tiles in the country. His book *Handmade Tiles* is the standard of the handmade tile movement, explaining his innovative tile fabrication, glazing, and decoration techniques. In 1996, Giorgini received the prestigious Tile Heritage Foundation's Award of the Year for promoting awareness and appreciation of ceramic surfaces in the United States. His work adorns many public spaces in New York City. Giorgini's artwork is in private and public collections around the world and is in the permanent collection of the Metropolitan Museum of Art in New York. He also taught the Architectural Tile Design course at Parsons School of Design for 15 years and has held tile-making workshops around the United States and abroad. In 2011, he designed the Commemorative Centennial Tile for the New York Public Library. (Courtesy of Dmitri Belyi.)

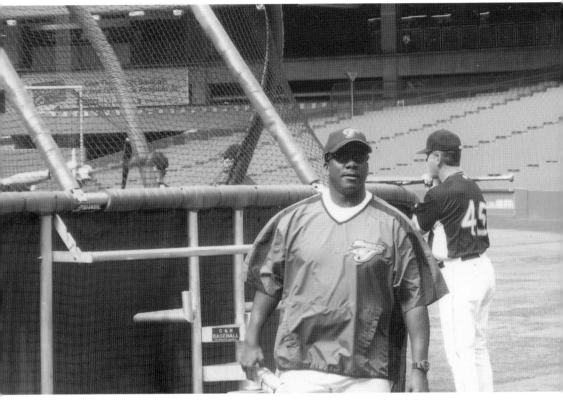

Michael Charles "Mickey" Brantley

Brantley grew up in Catskill. After one year at Columbia-Greene Community College, he played baseball for Coastal Carolina University. During his senior season, he was drafted by the Seattle Mariners in the second round. After three years in the minors, he made his big league debut with the Mariners in 1986. Brantley played outfield and designated hitter during parts of four big league seasons, 1986–1989, all for the Mariners. As a rookie in 1987, he led the team regulars in hitting with a .302 batting average and also had 14 homeruns and 54 RBIs in 106 games. He spent the 1990–1993 seasons with several minor league teams, finally finishing his playing career with the Yokiuri Giants in Japan. Brantley's son Michael Brantley is currently a regular with the Cleveland Indians. (Courtesy of Erica Brantley.)

Kay Stamer

Stamer has been the executive director of the Greene County Council on the Arts for over 30 years. In addition, Stamer is the program coordinator for the Arts Council's Youth ArtsReach after-school workshops and, until recently, Arts Education partnerships with schools in Greene, Columbia, and Schoharie Counties. As executive director of GCCA, she oversees regranting county funds to Greene County cultural organizations. She also managed the cultural side of the Riverside Market at the Catskill Point for 10 years. Stamer is on the steering committee for NYS Arts and served as a Capital Region advocacy coordinator for NYS Arts and the New York State Council on the Arts Cultural Blueprints initiative. Over the years, Stamer has received awards for her commitment from the GCCA, the Greene County Chamber of Commerce, the Columbia-Greene College, and the Catskill Mountain Foundation. Pictured from left to right are Michel Goldberg, Kay Stamer, and assemblyman Pete Lopez. (Courtesy of Kay Stamer.)

77th New York Regimental Balladeers

The Windham, New York, based balladeers are celebrating their 18th year and over 375 concert performances. They are dedicated to preserving the songs, tunes, history, and spirit of the Antebellum and Civil War period, one of the most turbulent times in American history. The original 77th New York Regimental band was formed in 1872 and was comprised of military personnel from Fulton, Essex, and Saratoga Counties who fought in the Civil War. The band flourished into the early 1900s when thinning ranks, as members answered the final taps, caused it to dissolve. The modern day balladeers have continued the philanthropic tradition that was established by the "Old Seventy-Seventh" helping to organize and perform at a number of concerts immediately following Tropical Storm Irene. The band raised over $8,000 in funds and leveraged an additional $30,000 in cleaning supplies, clothing, building materials, and volunteer services to assist families on the mountaintop.

The troupe performs regularly at encampments, museums, schools, colleges, historic sites, private parties, weddings, conferences, and living history events. Band members include John and Sharon Quinn, Bill and Barbara Lonecke, Jim Broden, Gisella Montanez-Case, Joyce Cockerham, Jennifer Brylinski, Frank and John Swarthout, Ray Smith, John Kenosian, Gus Truin, and Ron Burch. The balladeers have been recognized by the US Department of the Interior, the Rhode Island National Guard, and the NYS Military Museum for the quality and authenticity of their music. The band is the host for the annual Civil War Heritage Music Gathering & Encampment in Windham. This event, which is held on the first weekend of August each year, is considered to be one of the premiere living history events of its kind in the northeast. The band has also recorded and released several albums, the proceeds from which are used to support ongoing historic preservation and education efforts. (Courtesy of John Quinn.)

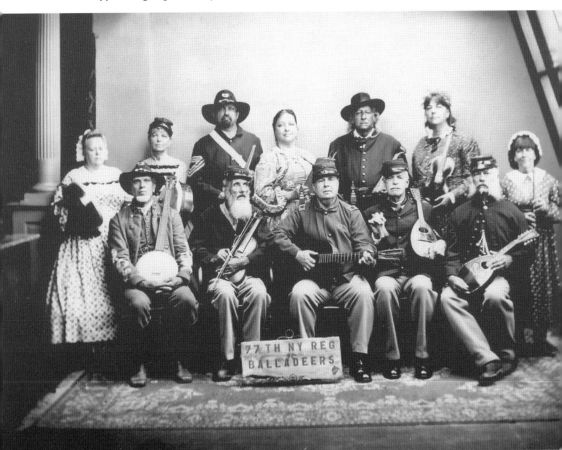

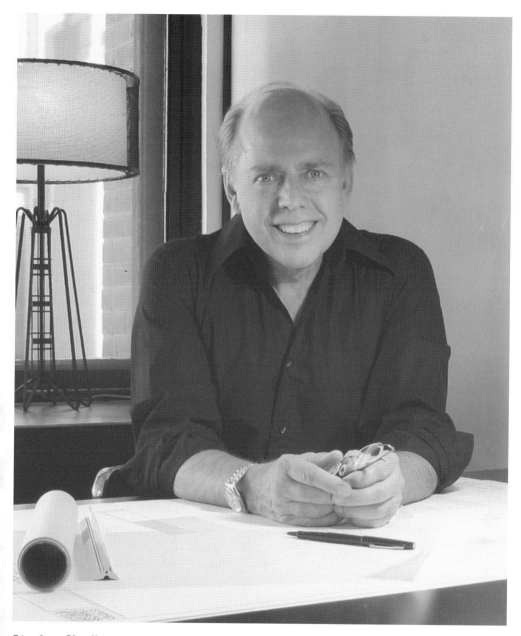

Stephen Shadley

Shadley began work as a scenic artist in Hollywood in the 1970s. He currently owns his own firm, Stephen Shadley Designs, Inc. His work has been featured in publications that include *Architectural Digest, House and Garden, New York Magazine,* and *Vogue,* among others. Shadley has been named in *Architectural Digest's* list of top-100 interior designers and architects since its inception in 1990. Shadley has done design work for Diane Keaton, Jennifer Aniston, Woody Allen, and Robert Altman to name a few. Since 1988, he has been dividing his time between his studio in New York City and a historic home in Greene County. Presently, he is completing work on reconstruction of a stone castle-like structure near Leeds, which was burned to the ground in the 1970s. Before the fire, the structure was a well-known landmark in the town. (Courtesy of Stephen Shadley.)

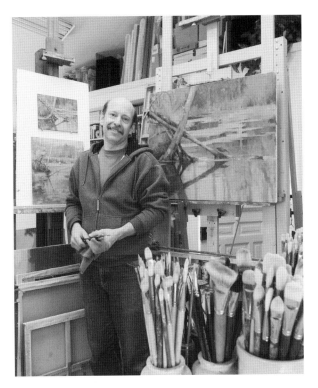

James Coe
Coe has contributed his artwork to several books, but is best known as the author and illustrator of the acclaimed Golden Field Guide *Eastern Birds*. His work is represented in the permanent collections of the Woodson Museum, which is host to the prestigious annual Birds in Art show, the New York State Museum, and the Museum of American Bird Art at Mass Audubon, among others. (Courtesy of James Coe.)

Larry Federman
Federman is the National Audubon Society's education coordinator for Rheinstrom Hill; Buttercup Farm; and in Greene County, RamsHorn-Livingston Sanctuary. Since joining the Audubon chapter, he has served in numerous capacities and is now the current president. Federman is also a well-known local nature photographer, and prints of his work are available in several mediums. A former full-time musician, Federman still plays guitar in local bands. (Courtesy of Larry Federman.)

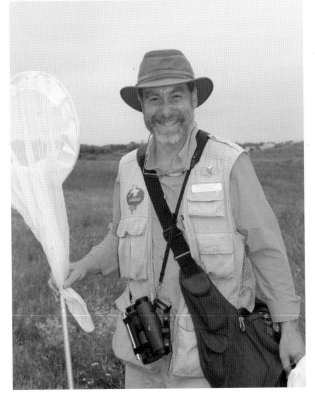

CHAPTER FOUR

Military, Legal, and Political Leaders

People who serve, there is no other way to describe our citizens who give of their knowledge, time, and effort to give back to their community and their country. Their jobs are not easy as they make decisions daily that affect the lives of those around them and sometimes even give their own lives to defend their country.

Greene County people have served in wars and conflicts from the Revolution to Afghanistan. William Plimley was awarded the Medal of Honor for his actions during the Civil War. Leonard Warren was a two-time prisoner of war in World War II. Joseph Anthony Morabito gave his life in Afghanistan providing physical security for high-ranking American personnel. One, Ruth Reynolds, was not recognized until 2010 for her participation in World War II as a member of the Women Airforce Service Pilots.

A free society also depends on those who dedicate themselves to the law and politics. They have served as local judges and New York State Appellate Court judges, as well as town supervisors, county legislators, New York State and national representatives, and even governors. Emory Chase served on New York State's highest court. T. Patrick Meehan served 38 consecutive years as Town of Windham supervisor, and Lucius Robinson and Washington Hunt were both governors.

Together, the people included in this chapter have contributed greatly to the county's past and present.

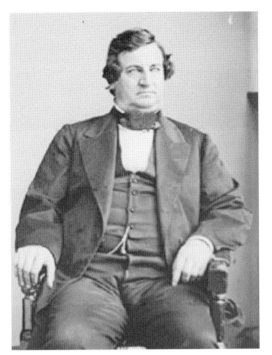

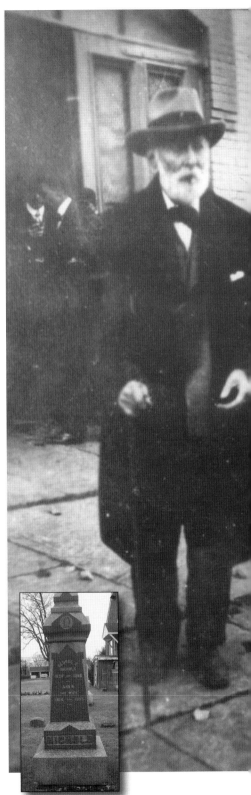

Lyman Tremain (June 14, 1819–November 30, 1878) (ABOVE)
Born in Oak Hill, Tremain began to pursue a career in the law at age 15. Over his lifetime, he was county district attorney, county judge, state attorney general, state assemblyman, and a congressman. He is perhaps best known for serving as a special counsel for New York State along with Wheeler Hazard Peckham in the prosecution and conviction of Tammy Hall's notorious Boss Tweed. (Courtesy of Library of Congress.)

George Sylvester Nichols (January 12, 1820–May 29, 1916) (RIGHT)
Born into a prominent Athens family, Nichols volunteered for the Cavalry when the Civil War broke out in 1861. He was given an appointment as a major in the 9th New York Cavalry in Chautauqua County and was quickly promoted through the ranks. In March 1865, he was brevetted a brigadier general. Nichols took part in more than 60 engagements during the war. (Right, courtesy of Lynn Brunner; inset, authors' collection.)

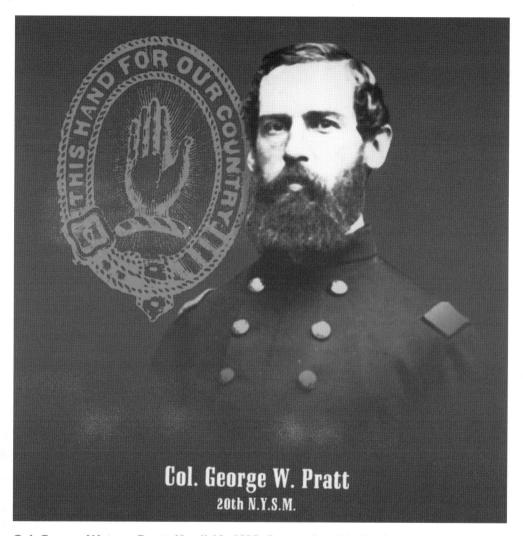

Col. George W. Pratt
20th N.Y.S.M.

Col. George Watson Pratt (April 18, 1830–September 11, 1862)

The son of the wealthy leather tanner Zadock Pratt, George Watson Pratt was born into a privileged life. As a young man, Pratt followed his father into the leather business. On May 23, 1855, he married Anna Attwood Tibbits, a niece of New York governor Horatio Seymour. At a young age, Pratt also became involved with the local militia, and at age 22, he was named colonel of the 28th New York State Militia. In 1857, he was elected to the New York State Senate representing Greene and Ulster counties. He also helped found the Ulster County Historical Society, serving as its first secretary. In 1857, Pratt's 28th NYS Militia was consolidated with the 20th NYS Militia (later designated the 80th), and Pratt was again named the colonel. On April 28, 1861, less than two weeks after Lincoln's call for 75,000 volunteer soldiers, Pratt's regiment left Kingston to join the Civil War. The last battle Colonel Pratt was involved in was on August 30, 1862, the Second Battle of Bull Run, where he suffered a freakish injury to his shoulder by a piece of buckshot about the size of a BB. The buckshot traveled to his spine and caused instant paralysis from the waist down. Over the next several days, he was transported to Albany where he died on September 11. In the forward to Seward R. Osborne's book about the colonel, John C. Quinn said this: "Colonel George Watson Pratt . . . was the model 'Citizen Soldier.' Like George Washington and many others, despite having an extremely successful and comfortable life, he was willing to put himself in harm's way for his country." (Courtesy of Seward R. Osborne.)

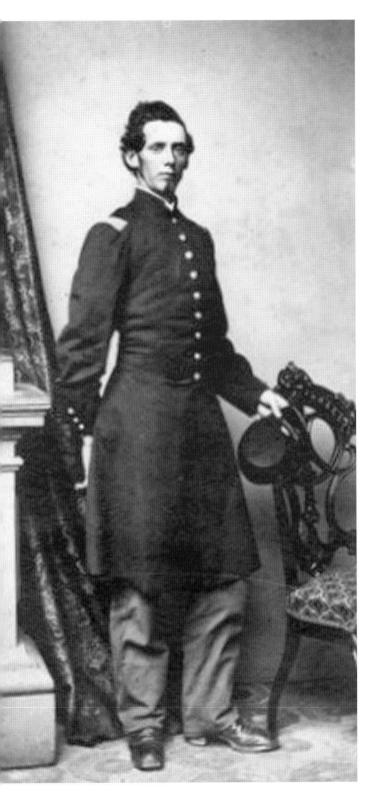

Ambrose Noble Baldwin (September 25, 1838– July 3, 1863)
Born in the Town of Lexington, Baldwin grew up on a farm in Jewett. He started teaching school at age 18, and in 1861 he answered Lincoln's call for troops to put down the secessionist uprising. He was instrumental in recruiting Company K of the 20th (later designated the 80th) New York State Militia, which included men from Jewett, Hunter, and neighboring towns. For his efforts, on September 16, 1861, he was made the company's captain. He went on to participate in the battles of Beverly's Ford, Warrenton Springs, Second Bull Run, Chantilly, and South Mountain. On September 17, 1862, at the Battle of Antietam in Maryland, Baldwin was wounded in the knee by a bursting shell. A fragment of the shell cut through three thicknesses of rubber coat that he wore at the time, creating a slight wound, which caused his knee to become lame. Baldwin and the 20th New York fought bravely at the three-day Battle of Gettysburg, but on the final day, near the end of Pickett's charge on Cemetery Ridge, he was mortally wounded by a piece of shell. His body was brought home and buried in Jewett Height's Cemetery. In 1988, through Seward R. Osborne's leadership and help from his friends, Ambrose Baldwin's obelisk gravestone, which was in dilapidated condition and dangerously leaning to one side, was restored to excellent condition. A rededication ceremony took place on July 3, 1988—a whole 125 years after Ambrose Baldwin received his mortal wound. (Courtesy of Seward R. Osborne.)

Maj. William Plimley (1839–1913)

William Plimley is the only man from Greene County to be awarded the Congressional Medal of Honor. At the time of the outbreak of the Civil War, Plimley was working as a printer in Catskill. He enrolled in the Army as a private in Cairo on August 12, 1862, and was mustered into Company K of the 120th New York State Volunteers in Kingston 10 days later. He was promoted to sergeant on November 1 of the same year, second lieutenant on August 23, 1864, and first lieutenant on October 27, 1864. He finished his military career as a brevet captain and aide-de-camp on the staff of Gen. Robert McAllister, commander of the 3rd Brigade, 3rd Division, 2nd Army Corps. Captain Plimley and the 120th New York State Volunteers participated in most of the fiercest fighting with the Army of the Potomac and were at Lee's surrender at the Appomattox Court House. Plimley was mustered out of service in Kingston on June 3, 1865. It was at Hatcher's Run at the siege of Petersburg, Virginia, that Plimley's actions would result in the Medal of Honor. On April 2, 1865, General McAllister received orders to regain ground that the Confederates had taken the night before. The general could not find a volunteer to take command of the left wing of the regiment. Lieutenant Plimley suffering from lack of sleep after working all night said he would take the command. The regiment was the 8th New Jersey Volunteers, and Plimley led them to victory by regaining the lost ground and capturing 118 prisoners. While leading his prisoners back to Union lines, the shells and shots coming in heavily, a tree was hit, and a falling limb hit Lieutenant Plimley driving him to the ground. The staff watching said that he should be recognized for his deeds, and he was made a brevet captain and later a major.

After the war, Plimley and his wife moved to New York City where he worked in several capacities, including a 28-year career with the post office, commissioner of jurors for New York City, and—at the time of his death—chief clerk of the New York City Board of Elections. Plimley was also one of the founders and a former president of the Greene County Society in New York City, a strong and active organization at one time, designed to strengthen the ties of county natives who had moved to the city. (Courtesy of Greene County Historical Society.)

Washington Hunt
(August 5, 1811–February 2, 1867)
Born in the Town of Windham, now part of Ashland, Hunt was the 17th governor of New York State. He was a lawyer and a member of the Whig Party. Hunt was elected three times to Congress and once as New York State comptroller before becoming governor in 1850. He is buried in Glenwood Cemetery in Lockport, New York. (Courtesy of Library of Congress.)

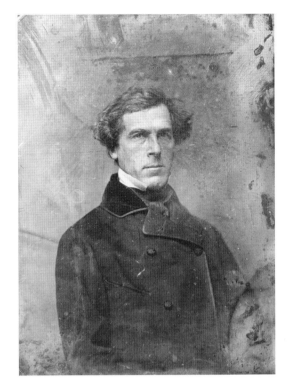

Lucius Robinson
(November 10, 1810–
March 23, 1891)
Robinson was the 26th governor of New York State. Born in Windham, at the age of 27 he became Greene County District Attorney. He was elected governor and served from 1877 through 1879. During his tenure, the new capitol in Albany opened. Robinson is remembered for his vigorous opposition to Tammy Hall politics, a fact that led to his reelection defeat in 1879. (Courtesy of Library of Congress.)

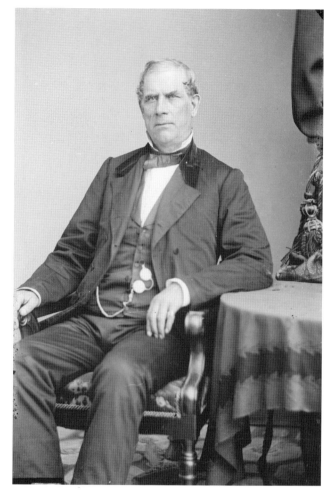

Thurlow Weed
(November 15, 1797–November 22, 1882)

Weed was born near the hamlet of Acra in the Town of Cairo. When he was two years old, his family moved to Catskill. Weed had only a year and a half of formal schooling and went to work at age eight for a blacksmith in Catskill. His pay was 6¢ a day. Next, he went to work as a tavern boy in Jefferson and then as a cabin boy for Captain Grant on the sloop *Ranger*. Not yet nine, he got to see New York City for the first time. He writes of the experience, "I remember as if it were yesterday, after carrying the small hair trunk of a passenger from Coenties Slip to Broad Street, finding myself in possession of the first shilling that I could call my own." Weed's life in Catskill ended when he went off to serve in the War of 1812. After the war, he got a job running printing presses for the *Albany Register*. While working there, he became interested in politics.

Weed supported Dewitt Clinton under whose administration the Erie Canal was built, and by 1824, he was working to ensure the successful presidential bid of John Quincy Adams. In 1825, he bought the *Rochester Telegraph* newspaper. On March 22, 1830, Weed published the first copy of the *Albany Evening Journal*, which was, from 1834 to 1856, the main Whig paper in the country. He controlled the Whig Party in New York State for many years by taking a pragmatic approach on many issues—opposition to slavery being the exception. He also played a role in the presidential nominations of William Henry Harrison (1840), Henry Clay (1844), Zackary Taylor (1848), Winfield Scott (1852), and John Charles Fremont (1856). All were Whigs except Fremont, who was a Republican.

In 1860, he hoped to guide his longtime friend William Seward to the party nomination for president of the United States. Weed failed in his attempt, but he got behind Lincoln and became a supporter throughout his administration as did Seward, serving as secretary of state. He did differ with Lincoln on the Emancipation Proclamation, believing that emancipation should be more gradual. Shortly after the Civil War, in 1867 Weed retired from public life and moved to New York City, where he died in 1882. (Courtesy of Library of Congress.)

John Francis Hylan (April 20, 1868–January 12, 1936)

Hylan was born in the town of Hunter where his family owned a farm. After trying farming, he moved to New York City where he became a lawyer and found work with the Brooklyn Union Elevated Railroad. In 1917, he was tapped as a dark horse candidate for mayor and won. In 1925, he lost to Jimmy Walker. Hylan is pictured in the center. (Courtesy of Library of Congress.)

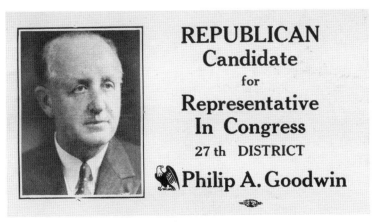

Philip A. Goodwin (January 20, 1882–June 6, 1937)

Goodwin was the last US congressman to be born and live in Greene County. He graduated from Albany Business College in 1902 and went into the steel construction business in Albany until 1916 when he bought a lumber business in Coxsackie. He was elected to the House of Representatives in 1932, where he served until his death in 1937. (Courtesy of Greene County Historical Society.)

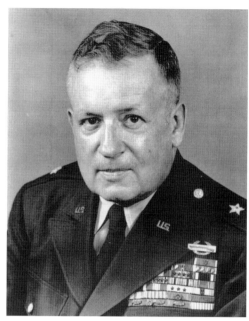

**Samuel Lyman Atwood "Slam" Marshall
(July 18, 1900–December 17, 1977)**
Nicknamed "Slam" because of his initials, Marshall spent his formative years growing up in Catskill. During World War II and the Korean War, he was the chief Army combat historian. He authored some 30 books about warfare, including *Pork Chop Hill: The American Fighting Man in Action*, later made into a movie starring Gregory Peck. (Courtesy of US Army.)

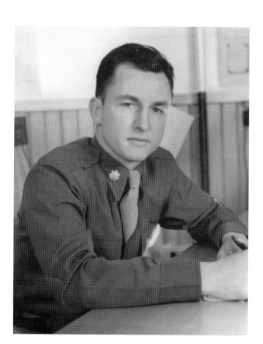

**Donald Saunders
(March 28, 1913–June 27, 1958)**
Born and raised in Athens, General Saunders was commander of the 57th Air Division. He was the senior officer on board a group of four KC-135 jet Stratotankers attempting to set a transatlantic speed record between the United States and England when his plane crashed taking off from Westover Air Force Base in Massachusetts. Saunders and 14 others aboard were killed. (Courtesy of Greene County Historical Society.)

William C. Brady (1852–1931) and William E. Brady (1889–1970)

At one time, William C. Brady represented Greene County as a member of the New York State Assembly. He worked as an undertaker in the funeral home established in Athens by his father George C. Brady in 1840. In 1911, operations were expanded to Coxsackie. William C.'s son William E. Brady continued the business and served in the New York State Assembly as well from 1940 to 1962. After World War II, William E.'s stepson William E. Tremmel took over the business, and the Athens location was closed in 1969. Finally, in 1989, the funeral home was sold after four generations and 149 years in the same family. The business still operates under the same name, W.C. Brady's Sons Inc. Funeral Home (Left, courtesy of William Palmer; below, authors' collection.)

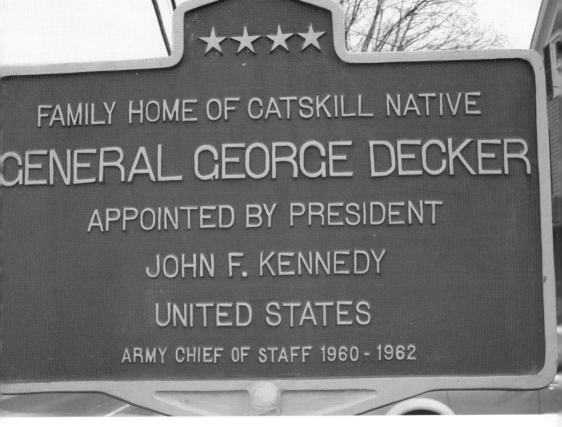

★★★★

FAMILY HOME OF CATSKILL NATIVE
GENERAL GEORGE DECKER
APPOINTED BY PRESIDENT
JOHN F. KENNEDY
UNITED STATES
ARMY CHIEF OF STAFF 1960 - 1962

George H. Decker (February 16, 1902–February 6, 1980)
Decker was born in Catskill and completed a degree in economics and the ROTC program at Lafayette College in Pennsylvania. He joined the Army as a second lieutenant in 1924. Despite the fact that Decker was not a West Point graduate, he was named chief of staff of the US Army in 1960 by Pres. John F. Kennedy. General Decker retired at the end of his tenure as chief of staff of the Army on September 30, 1962—two weeks before the Cuban Missile Crisis. General Decker has been recognized with a New York State Historic Marker in front of his boyhood home on West Bridge Street in Catskill and a plaque near the entrance to the Catskill High School Auditorium. (Authors' collection.)

George L. Cobb
(April 14, 1926–December 26, 2004)
Cobb, a graduate of Albany Law School, may have been the longest-serving judge in Greene County history. He first served as Greene County Surrogate and Family Court judge from January 1, 1964, to December 31, 1973, and on November 5, 1969, he was elected to the New York State Supreme Court where he served for 34 years until his retirement in 2002. (Courtesy of Greene County Historical Society.)

Emory A. Chase (August 31, 1854–June 25, 1921)
Chase was admitted to the bar in 1880. He became a justice of the New York State Supreme Court (Third District) in 1897 and served there until 1920 and from 1900 on the Appellate Division, Third Department. In 1906, he was appointed to the New York State Court of Appeals where he served until 1912. In 1920, he was elected to a full 14-year term on the Court of Appeals. Chase is pictured on the right. (Courtesy of Library of Congress.)

Leonard Hall Warren (September 15, 1913– March 12, 2006) During World War II, Warren served as a captain in an artillery company in North Africa before being captured in 1942 and imprisoned in Italy. A year later, he escaped from a prison train—an episode not unlike the one in David Westheimer's book and the movie *Von Ryan's Express.* Westheimer was imprisoned with Warren at one point as was Joseph Frelinghuysen, who also escaped and wrote the book *Passages to Freedom.* Warren was recaptured by the Germans after several months and sent to another prison camp for almost two years until being liberated by the Russians in 1945. After returning home, he resumed his law practice with his brother James Warren, became president of the National Bank of Coxsackie and gave back to the community in many ways. (Courtesy of Florence Warren.)

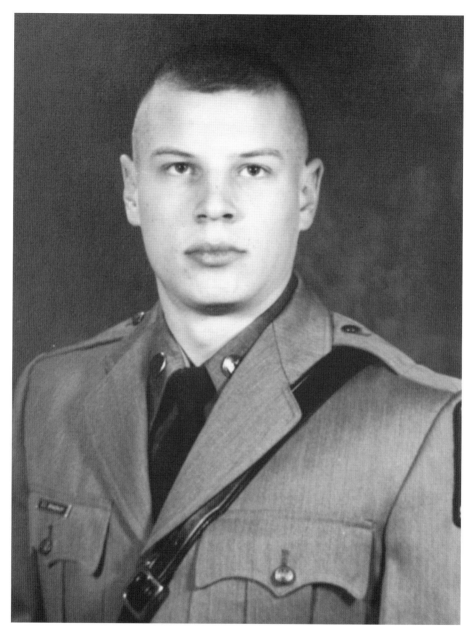

David C. Brinkerhoff (August 29, 1977–April 25, 2007)

Trooper Brinkerhoff, an eight-and-a-half-year veteran of the New York State Police, was accidentally shot and killed in an intense gun battle on April 25, 2007. Another trooper was also wounded in the shootout with Travis Trim, an assailant who had wounded a New York State trooper the previous day. Brinkerhoff lived in Coxsackie with his wife Barbara and seven-month-old daughter Isabella Grace. To honor the fallen trooper, the Capital Bicycle Racing Club established the Trooper Brinkerhoff Memorial Bike Race Series. The race series takes place in early spring each year on three consecutive Saturdays in Coxsackie and Athens. The race series raises money for a Coxsackie-Athens High School scholarship in memory of Trooper Brinkerhoff, the Coxsackie Police Athletic League, Catskill and Coxsackie ambulances, and the Athens Food Pantry. (Courtesy of New York State Police.)

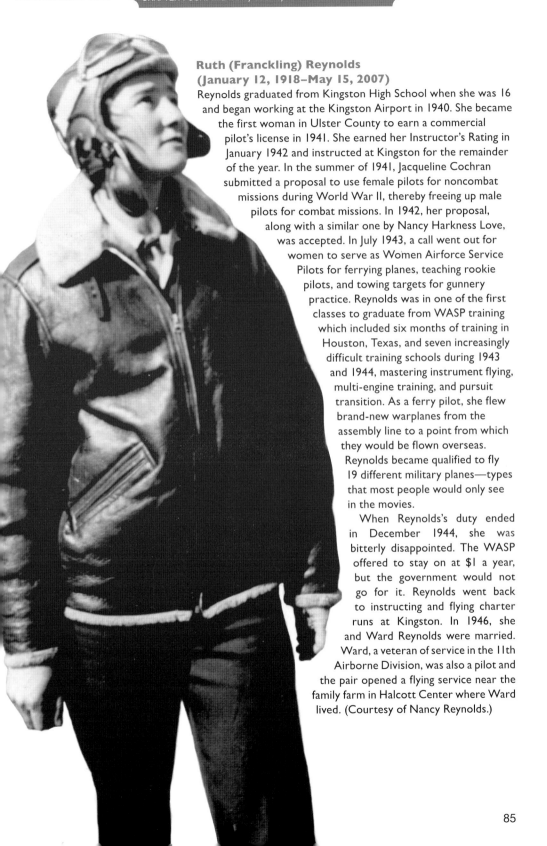

Ruth (Franckling) Reynolds
(January 12, 1918–May 15, 2007)

Reynolds graduated from Kingston High School when she was 16 and began working at the Kingston Airport in 1940. She became the first woman in Ulster County to earn a commercial pilot's license in 1941. She earned her Instructor's Rating in January 1942 and instructed at Kingston for the remainder of the year. In the summer of 1941, Jacqueline Cochran submitted a proposal to use female pilots for noncombat missions during World War II, thereby freeing up male pilots for combat missions. In 1942, her proposal, along with a similar one by Nancy Harkness Love, was accepted. In July 1943, a call went out for women to serve as Women Airforce Service Pilots for ferrying planes, teaching rookie pilots, and towing targets for gunnery practice. Reynolds was in one of the first classes to graduate from WASP training which included six months of training in Houston, Texas, and seven increasingly difficult training schools during 1943 and 1944, mastering instrument flying, multi-engine training, and pursuit transition. As a ferry pilot, she flew brand-new warplanes from the assembly line to a point from which they would be flown overseas. Reynolds became qualified to fly 19 different military planes—types that most people would only see in the movies.

When Reynolds's duty ended in December 1944, she was bitterly disappointed. The WASP offered to stay on at $1 a year, but the government would not go for it. Reynolds went back to instructing and flying charter runs at Kingston. In 1946, she and Ward Reynolds were married. Ward, a veteran of service in the 11th Airborne Division, was also a pilot and the pair opened a flying service near the family farm in Halcott Center where Ward lived. (Courtesy of Nancy Reynolds.)

Clarence "Larry" D. Lane (March 17, 1921–December 7, 1998)
Lane served 24 consecutive years as a New York State assemblyman from Greene County. In 1968 and 1978, he garnered over 65 percent of the vote in gaining reelection. Some of Lane's accomplishments for Greene County included legislative support for the ski business, flood control dams, improvements to State Route 23, and the creation of the Columbia-Greene Community College. Pictured on the right is Larry Lane with Gov. Nelson A. Rockefeller. (Courtesy of Eleanor Lane.)

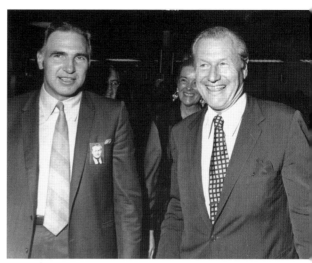

T. Patrick "Pat" Meehan (January 9, 1948–November 15, 2009)
At the time he was first elected supervisor of the Town of Windham in 1971, Meehan was believed to be the youngest supervisor in New York State and was elected 19 more times spanning 38 consecutive years before his death. Among his many accomplishments was a landmark New York City watershed agreement that protected watershed towns in a multi-county area. (Courtesy of Denise Meehan.)

Joseph Anthony Morabito (June 10, 1958– June 8, 2013)

Morabito of Haines Falls was killed on his second tour of duty in Afghanistan. He and two army officers were victims of a surprise attack by an Afghan soldier they were training. The gunman was killed by American forces. Morabito's law enforcement career spanned 34 years, most of it with the federal government starting with the Navy in 1978. In 2006, he was hired as an international law enforcement professional by Dyncorp International and the US State Department and served his first of two tours of duty in Iraq. In 2008, Morabito worked as an instructor and advisor to the Haiti National Police Force. In 2011, Morabito was first deployed to Afghanistan where his duties included training the Afghan National Police and providing physical security for high-ranking US military personnel. The year after his death, his daughter Toniann helped organize DASH: Courage and Honor, a 5-K run/walk in tribute to Morabito. The event raised $7,500 for veterans service organizations. (Courtesy of *Columbia-Greene Media*.)

Franklin M. Berry (September, 22, 1920–January 2, 1999)
Born in Poughkeepsie, Berry enlisted as an aviation cadet through the Elks' FDR group in the summer of 1942. He received his commission as second lieutenant in the Army Air Division in February 1943 and was assigned to pilot a B-17 "Flying Fortress" bomber. (He was known as "Skin and Bones" for his tall and slender build.)

In England, Berry established himself as a uniquely reliable and capable pilot. On one harrowing mission, while acting as 8th Air Force squadron leader, he piloted his ship home with less than 50 percent of controls operating. On another, he landed with a 12-pound flak shell lodged in the wing, at the time the largest recorded ordinance in a returned ship. Waist gunner, Staff Sgt. William C. Dow said, "Our ship was in bad shape, it had suffered many flak hits and we all had our 'chutes' on ready to abandon ship . . . but while we were in the air he [Berry] showed no sign of fear. His voice was even and collected at all times. His calm helped us all a lot and as usual, he brought us back."

Among other medals, Berry received the Distinguished Flying Cross and an Air Medal with Three Oak Clusters (1942–1945). He flew on the famous Schweinfurt mission, in which 69 of 300 planes were lost to Luftwaffe fighters en route to bombing a key ball-bearing plant.

Upon completing over 25 missions, Berry returned to the Hudson River Valley, where he became resident manager of the Central Hudson office in Catskill. (Courtesy of Kevin Berry.)

George J. Pulver

In 1995, Pulver was elected to the position of Greene County Family and Surrogate's Court judge and has also served as an acting Supreme Court justice since then. Starting in 2007, he served on the committee that oversaw the over $12-million renovation of the historic Greene County Courthouse. Pulver personally took charge of gathering historical paintings and artifacts for permanent display in the rotunda of the building. (Courtesy of *Albany Times Union*.)

Daniel K. Lalor

Lalor served as the county public defender, district attorney, county judge, family court judge and surrogate—the only person in the history of the county to hold all of these offices. He also served as Acting Supreme Court Judge and organized the first County Drug Court. After serving for 20 years as judge, Lalor was appointed a New York State judicial hearing officer presiding over cases throughout a seven-county district. (Courtesy of Daniel Lalor.)

Wayne Speenburgh
After a career in high-level positions with the US Postal Service, Speenburgh finished his career as postmaster in his hometown of Coxsackie. Before his retirement, he served as chairman of the Coxsackie-Athens School Board overseeing a major expansion to the campus in Coxsackie. Speenburgh is currently chairman of the Greene County Legislature, where he spearheaded recovery efforts after the destruction from Hurricane Irene in 2011. Wayne Speenburgh is pictured on the right with Peter Lopez on the left. (Courtesy of Greene County Historical Society.)

George L. "Larry" Gunderman
Raised in Coxsackie, Gunderman graduated from West Point in 1962. He left active duty in 1973 and began a career in the Army Reserve. In his final assignment as a major general, Gunderman returned to active duty in 1995 as the deputy commander of the Army Reserve Command at Fort MacPherson, Georgia, where he ran the day-to-day operations of this 700-person organization. (Courtesy of Theron Gunderman.)

CHAPTER FIVE

Inventors and Entrepreneurs

Greene County can claim many people who had a flair for invention and starting important businesses. This entrepreneurial spirit started in the earliest time and continues today.

One of the first businessmen and inventors was William Edwards, who invented leather-rolling machinery, which revolutionized the tanning industry. Edwin Drake, born in Greenville, is credited with developing a way to successfully drill for oil in Titusville, Pennsylvania. In the 20th century, Herman Knaust's invention of the tray-crop system for growing mushrooms led to Coxsackie becoming known as "the mushroom capital of the world" for a time.

Agriculture has always been an important business in Greene County. Some who still engage in this are the Van Slykes, Storys, and Zimmermans (Black Horse Farm). Manufacturing businesses over the years in Greene County have included pottery making, leather tanning, shipbuilding, gun making, and most recently the making of skincare products and aircraft parts. Other people left the county to engage in retailing, automobile manufacturing, railroad building, and construction. Still others have enhanced the lives of everyone through developing the tourism industry in Greene County.

Here are the stories of the contributions people have made to the story of Greene County over two centuries ago and continue to make today.

Luman Reed (1787–1836)

When he was about two years old, Reed's family moved to Coxsackie. In 1815, he established a wholesale dry goods and grocery business on Front Street in New York City. Over the years, Reed developed a passion for collecting contemporary American art supporting young artists such as Thomas Cole and Asher B. Durand. He commissioned some of Cole's most famous works including the *Course of Empire* (1834–1836). Reed died midway through the completion of the series. His art collection was donated to the New York Historical Society in 1858 and is one of the most important early 19th-century collections of American art that survives intact. The Reed family is still remembered in Coxsackie because the main business district where Reed's uncle Roswell Reed had his grocery store in the 19th century is still called Reed Street. (Courtesy of Library of Congress.)

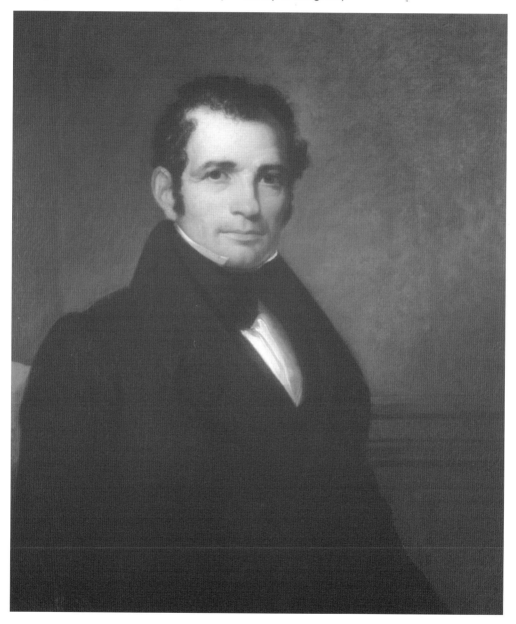

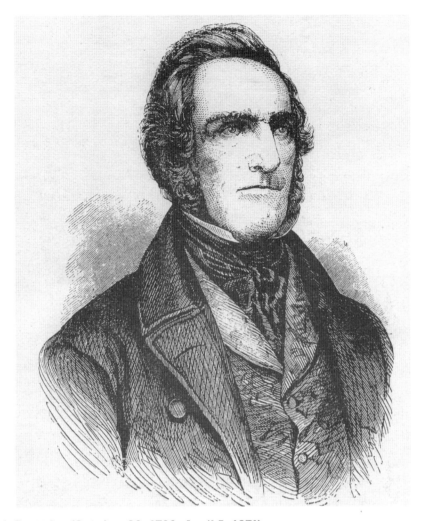

Zadock Pratt Jr., (October 30, 1790–April 5, 1871)
Pratt was a leather tanner and member of the US House of Representatives. He built the largest shoe leather tannery in the world at the time in Prattsville, the town named in his honor. He also built the town to accommodate the labor force necessary to operate the tannery. During his time as a tanner, Pratt financed many smaller tanneries in the Catskills, as well and one in Pennsylvania as a joint venture with the financier Jay Gould who was born and raised a short way from Prattsville in Roxbury, New York. Pratt was elected to the US House of Representatives in 1836 and 1842. While a congressman, Pratt supported legislation to create the Bureau of Engraving and Patents, construct buildings in Washington, DC, of marble or granite instead of sandstone, complete the Washington Monument, reduce the cost of postage from 25¢ to 5¢ and initiate the first survey for the Transcontinental Railroad. Pratt was so proud of the last two accomplishments that the epitaph on his gravestone reads, "WHILE A MEMBER OF CONGRESS MOVED THE REDUCTION OF POSTAGE A.D. 1838 AND THE SURVEY FOR A RAILROAD TO THE PACIFIC A.D. 1844." With regard to the postage rate reduction, Pratt argued that high postage costs disproportionately affected the poor and that it was effectively a tax on intelligence, as it hindered the free passage of information. Pratt was married five times. All of his wives except the last predeceased him. Pratt's only son, Col. George Watson Pratt, was commander of the 20th New York State Militia, which was heavily represented with Greene County men. (Courtesy of the Pratt Museum.)

James Bogardus (March 14, 1800–April 13, 1874)
Born in Catskill, Bogardus has many inventions to his credit, but he is most famous for constructing the first five-story-tall cast iron building in the United States for which he took out a patent in 1850. The success of the cast-iron exteriors from 1850 to 1880 led to the adoption of steel-frame construction of buildings. A number of Bogardus's buildings still stand. (Courtesy of New York City Landmark Preservation Commission.)

Edwin Laurentine Drake (March 29, 1819–November 9, 1880)
Drake, also known as Colonel Drake, was born in the Town of Greenville and is credited with being the first to successfully drill for oil in the United States. Drake's method of drilling inside a pipe to prevent borehole collapse was developed in Titusville, Pennsylvania, and is still used today by many companies to drill for hydrocarbons. (Courtesy of Library of Congress.)

Henry Meiggs (July 7, 1811–September 30, 1877)

Meiggs left Catskill at the age of 24 to start a lumber business in New York City. Two years later the Panic of 1837 swept the nation and his business was ruined. After another lumber business failure in Brooklyn, he finally found success during the California Gold Rush when he went to San Francisco with a cargo of lumber that he sold for 20 times its cost. In San Francisco, he quickly got into real estate speculation building warehouses, wharfs, sawmills, and schooners. Meiggs wharf in San Francisco is now known as the famous Fisherman's Wharf. By 1854, he was in debt again and had committed fraud as well. Before the fraud was discovered, he, his family, and his brother left San Francisco on the brig *American* and headed for South America. Once again Meiggs recovered, and in 1858, four years after his arrival in Chili, he contracted with the government to construct railroads, which made him wealthy again. Next, he undertook the building of six railroads in Peru of which three were completed and the remainders were in the course of construction at the time of his death. Meiggs's success in South America made it possible for him to meet all of his former obligations in California, which he paid in full with interest. At the time of Meiggs's death in September 1877, Peru had approximately 1,200 miles of railroad track of which more than 700 miles had been built by him.

In 1977, one hundred years after Meiggs's death and as result of a campaign by his supporters, Judge Harry W. Low of the California Superior Court in San Francisco granted a motion to quash the indictment against Meiggs stemming from the fraud he committed while living there. The grounds for the motion were that Meiggs had rehabilitated himself in the intervening years after he committed the fraud. Not only did Meiggs try to pay back the people he had defrauded over the years he spent in Chili and Peru, he also became known as a great philanthropist. The Meiggs website says this about Meiggs: "At times Henry Meiggs was a scoundrel, but he had his good traits and he built some remarkable railways. Few ever accused him of shoddy workmanship or the use of any but the best materials." (Courtesy of Library of Congress.)

Nathan Clark (August 10, 1787–January 15, 1880)

In 1805, Clark formed a partnership with his brother-in-law, Capt. Thomas Howe, to start making salt-glazed pottery in Athens. Howe died in 1813, but the business ran continuously until 1900. By 1816, Clark was shipping his products as far south as Charleston, South Carolina, and Savannah, Georgia. Over time, Clark also sent his apprentices out to establish pottery-making operations in other locations in New York State, including Lyons, Kingston, Cornwall, Oswego, Mount Morris, and Rochester. With the exception of a five-year break in family ownership, the business was run continuously by three generations of the Clark family until 1893, when Thomas and Edward Ryan took over operations for the last seven years. Many Greene County residents proudly display the salt-glazed, hand-painted decorated stoneware in their homes. (Right, courtesy of *Beer's History of Greene County*; below, authors' collection.)

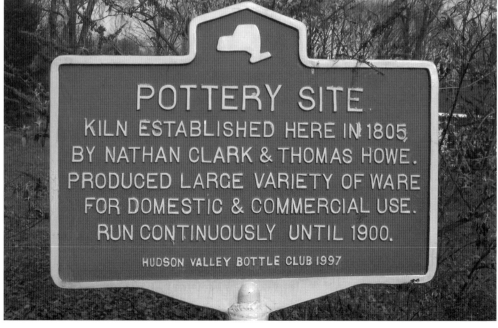

POTTERY SITE
KILN ESTABLISHED HERE IN 1805
BY NATHAN CLARK & THOMAS HOWE.
PRODUCED LARGE VARIETY OF WARE
FOR DOMESTIC & COMMERCIAL USE.
RUN CONTINUOUSLY UNTIL 1900.
HUDSON VALLEY BOTTLE CLUB 1997

James Reid (1827–1898)

Reid was born in Belfast, Ireland. He moved with his family to New York in 1857. A skilled mechanic and inventor, he was granted his first patent on a pistol in 1863. In 1865, Reid moved to Greene County because of the abundant waterpower on the Cauterskill Creek and built a two-story brick factory for the manufacture of pistols a few miles from Catskill. Altogether, nine different models of revolvers were made by Reid at the site over the next 19 years. The most popular gun was a small .22 caliber marked "My Friend" and called the Knuckleduster. The design of the gun gave the user a version of brass knuckles as well as a small pistol like a Derringer—thus the name. Over 9,000 of this model were made. (Left, courtesy of Greene County Historical Society; below, courtesy of Robert Carl.)

George W. Harding (October 27, 1827–November 18, 1902) Harding, a wealthy patent attorney from Philadelphia had a tremendous impact on the area for a time. As Mary Van Wagonen, granddaughter of Catskill Mountain House owner Charles L. Beach told the story. At one meal while summering at the Mountain House he ordered capon. He was told they had not arrived from Philadelphia. Harding was so upset that he decided to build his own hotel. The Hotel Kaaterskill opened in 1881. When fully completed, it could accommodate 1,000 guests and was a mile around its perimeter. At the time, it was believed to be the largest wooden-frame structure in the world. Harding's family owned the hotel for another 19 years after his death and sold it in 1921. In 1924, a kitchen fire spread and destroyed the entire structure. (Courtesy of Greene County Historical Society.)

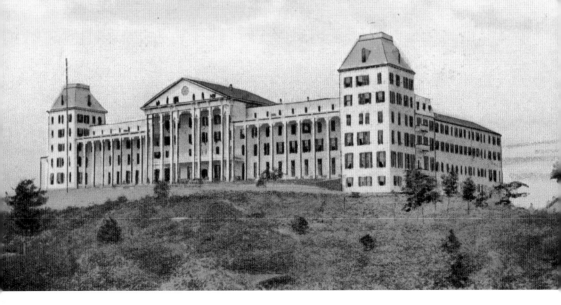

Ezra Fitch (September 21, 1865–June 16, 1930)
Fitch was born in Coxsackie to a family that ran a profitable freighting business from docks they owned on the Hudson River. He lived the life of a privileged young man.

He earned a law degree from New York University in 1894 and was married in Brooklyn to Sarah Huntington Sturges three years later. Fitch enjoyed the outdoors and spent his leisure time yachting, climbing the Adirondacks, and fishing the streams of the Catskills—perhaps an outgrowth of his boyhood spent in Greene County. Because of his interest in outdoor pursuits, Fitch became a devoted customer of a high-end sporting goods store in New York City run by David Abercrombie. By 1900, Fitch had become a partner in the business, and by 1904 the store was called Abercrombie & Fitch. The partnership only lasted until 1907, when Abercrombie sold his share of the business to Fitch. During Fitch's era of leadership, the company experienced great success expanding into a number of markets and creating a mail-order catalog in 1909. The introduction of the game Mah-Jongg from China in his store in 1920, still played by many people today, is attributed to Fitch. In 1928, he retired from the company and died at the fairly young age of 64 in Santa Barbara, California. (Courtesy of Waltham Museum.)

FRANKLIN AUTOMOBILES are built in three chassis sizes, four- and six-cylinder, with bodies covering the whole range of touring cars, runabouts, close-coupled cars, limousines, landaulets and town cars.

The features which distinguish the Franklin automobile are light weight, air cooling, full-elliptic springs, large wheels, large tires, wood chassis frame. These features give the Franklin its superiority in comfort, reliability and economy—the prime qualities on which the merit of every automobile is finally determined.

You settle the tire question when you select your automobile.

So well is the Franklin designed and so well tired is it that it is the only automobile with which tire trouble is not a factor. It is light and resilient and therefore easy on tires. In addition, the tires used are so large that heavy loads and fast driving do not weaken them.

Comfort the great essential.

The Franklin is the easiest riding of all automobiles; you go farthest in a day and make the fastest time.

Its full-elliptic springs have double the elasticity and shock absorbing ability of semi-elliptic springs. Its wood chassis frame, lighter and stronger than a pressed steel frame, absorbs instead of transmitting vibration. The Franklin is easy for its passengers and easy on itself.

The Franklin owner does not have to pay any attention to cooling.

Franklin air cooling, with no mechanism, is superior to any system of water cooling because it produces as good and better results without liability of trouble. It will not overheat or freeze; it will not get out of order. It is so simple and effective that it causes no concern whatever.

The charm of rapid motion, the delight of winding roads, the fascination of graceful speed on hills, the exhilaration of responsive power, the joys of long trips—all of this finds highest expression in the Franklin. There are ease and security with no thought of tire or other trouble.

H H FRANKLIN MANUFACTURING COMPANY Syracuse N Y
Licensed under Selden Patent

The Franklin catalogue is sent free on request

Herbert H. Franklin (September 1, 1866–July 7, 1956)

Franklin moved to Coxsackie from Broome County at age 19 to work for his uncle William P. Franklin as a printer's apprentice. His uncle was the owner of a local printing business and publisher of the weekly *The Coxsackie News*. Before long, he was made assistant editor and organized a local board of trade. As secretary of the board, he was able to attract the Kennedy Valve Company and a shirt factory from Troy to Coxsackie. He also became an agent for Columbia bicycles and opened a store in town to rent and sell them. With new business locating to Coxsackie, Franklin opened a real estate and insurance office with a partner, Frank Bedell. The office also served as the hub for the first telephone line linking Albany and Coxsackie. Messages were relayed to local residents by Columbia bicycle. In 1892, he relocated to Syracuse where he became involved in various manufacturing enterprises. After founding the H.H. Franklin Manufacturing Company in 1893, he teamed with engineer John Wilkinson in 1901 to develop an air-cooled engine. In 1902, he formed the Franklin Automobile Company to market the Franklin automobile. The company sold about 150,000 cars over the course of more than 30 years in existence. There is a Franklin Auto Museum in Tucson, Arizona. (Courtesy of Greene County Historical Society.)

Marion C. Albright (January 8, 1885– November 7, 1950) Albright was considered one of the most progressive farmers in Greene County. He won first prize in the National Farm Essay contest and was featured in Central Hudson Gas and Electric's monthly newsletter in May 1930 titled *Central Hudson Progress*. The theme of his essay was "How Electricity Helps the Farmer," and Governor Roosevelt presented Albright with his award on April 3, 1930, at the executive mansion in Albany. Albright's essay begins, "Six years ago we began using electricity for lighting, laundry work, and other small devices about the farm. We now use thirty-three electrically operated appliances." Albright concludes his essay by saying, "Electricity is a willing, efficient, tireless, and grouchless 24-hours-per-day servant and will, I believe, bring to the farmer greater returns, intellectually, physically, and financially, than anything invented or discovered in the past." (Courtesy of Greene County Historical Society.)

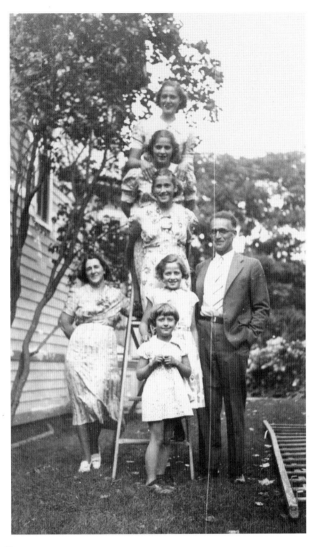

Thompson Family

The Thompson family's involvement in Greene County tourism began in 1886 when Ira and Christina bought the Thompson House in Windham. The ownership was continued by their son Herbert and then his son Ferris, who married Anita Lucretia West. Together, Anita and Ferris had five daughters, four of whom, with their spouses, would go on to own and operate well-known resorts around the county. Eleanor Thompson Lane and her husband, Larry, owned the Windham Arms, which is now the Winwood Inn. Roberta Thompson Christman and her husband, Stanley, are the former owners of Christman's Windham House, now owned by their children. Marianne "Mickey" Thompson Goettsche and her husband, John, were owners of the Thompson House. It has now been passed down to the newer generations of the Goettsche family and the sixth generation in the Thompson linage. Ruth Thompson Stevens and her husband, Pierce, owned the Greenville Arms in Greenville. The other daughter, Barbara Thompson Tolley, who moved from the area and lived in Wisconsin for a period of time, has returned to the mountaintop and is continuing the family tradition started by her mother of chronicling the family's history and accomplishments. Ferris and Anita Thompson are pictured here with their five daughters. From top to bottom are Ruth, Eleanor, Roberta, Barbara, and Marianne. (Courtesy of Barbara Tolley.)

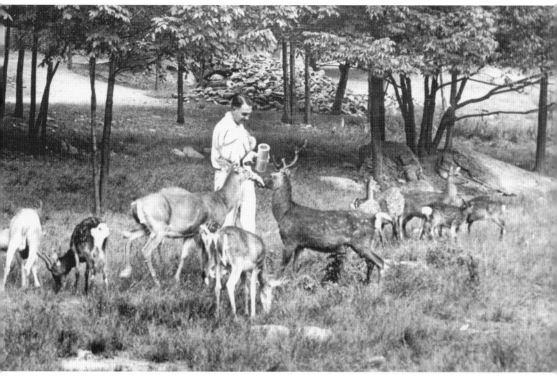

Roland Lindemann (August 20, 1906–1998)

Born in Berlin, Germany, Lindemann immigrated to the United States in 1923 and with two friends, traveled around the country for two years before Lindemann settled in New York City. After taking some courses through an extension school he opened a small loan business. Saving his money, he was able to buy some land in the Catskills near Cairo. There, he kept a few animals such as white-tailed deer, goats, and donkeys. At first, he kept the property as a weekend retreat where people he worked with and those who heard of it came to visit what was called "Lindemann's Deer Farm." No admission was charged. In 1943, Lindemann sold the loan business, moved to the Catskill area, and opened the Catskill Game Farm, a family business that would continue until 2006. During the early years, the family also did 14 off-site Christmas exhibits including one at the former Gimbel's Department Store in Manhattan. In 1958, the Game Farm was recognized by the Department of Agriculture as the first privately owned zoo. This designation allowed Lindemann to import rare and vanishing species from around the world for display in his zoo. The same year, he received the largest shipment of animals ever imported from Australia, including kangaroos and psittacine birds. Half the birds were sold to Lindemann's friend August Busch, who started Busch Gardens at Grant's Farm in St. Louis, Missouri, at that time. Over the years, animals were also imported from other continents including the first rare Przewalski horses from the Gobi Desert found in a Munich zoo and white rhinos from South Africa.

Kathie Schulz, Lindemann's daughter, and her husband, Jurgen, bought the farm from Kathie's parents in 1989. At one point the collection of animals grew to roughly 2,000 from 150 species. The entire operation consisted of close to 1,000 acres with 136 acres open for public viewing in the spring, summer, and fall. At its peak in the 1960s, the Game Farm experienced up to 500,000 visitors a year. By 2006, however, visitors had declined to about 100,000 and stricter government regulations made it difficult to continue. On August 1, 2006, the Schulzes announced they were closing the family business. The zoo was a labor of love for the Lindemanns and Schulzes, and its closing was a sad day for Greene County residents and summer visitors as well. (Courtesy of Greene County Historical Society.)

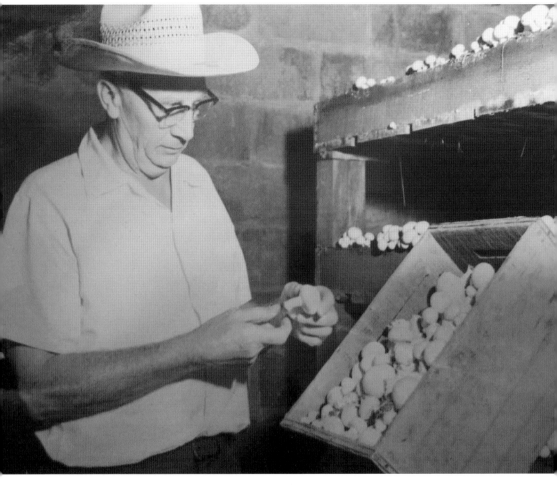

Herman and Henry Knaust

At one time, the Knaust brothers, Herman and Henry, ran the largest mushroom growing and distribution business in the world. While parts of their operations were in other counties in the Hudson Valley and elsewhere, much of it was located in Greene County. Initially, in about 1918, the brothers began using abandoned icehouses to grow mushrooms. In time, they found man-made caves provided a more suitable environment. They also built the 120,000-square-foot tray-crop building in Coxsackie. It was essentially a factory where almost everything was done prior to actually growing the mushrooms, which was done elsewhere. Initially the mushrooms were shipped raw, but in time the brothers were also running canneries on Railroad Avenue in Catskill and in Hudson that canned mushrooms and mushroom soup that was marketed under different brand names. At their peak, the Knaust Brothers were the largest mushroom producer in the world and had about 1,000 employees and 250 trucks on the road. One of Henry Knaust's sons estimates that peak production was over 12 tons of mushrooms a day. He also said that over time other families began growing mushrooms and many sold their harvests to the Knausts for canning. Essentially, the brothers controlled every step including producing the mushroom spawn, building the trays, harvesting, packaging, marketing, and shipping. Two factors did the mushroom business in. One was the union, which drove up the cost of labor, and the other was foreign competition—principally from Taiwan. Pictured is Herman Knaust inspecting a mushroom crop. (Courtesy of Iron Mountain.)

Ralph D. Hull

Hull spent his whole life as a farmer in the town of Durham. He recalls when electricity and the first telephones with a crank on the side came to the farm. He says, "I was born before the days of plastic cups, nylon hose, rock and roll, air conditioning, frozen foods, credit cards, and ballpoint pens." In 2011, at age 93, Hull had his first book published titled *A Lifetime of Experiences and Memories*. The book is a resource for learning about rural life during the last century. (Courtesy of Janet Nelson.)

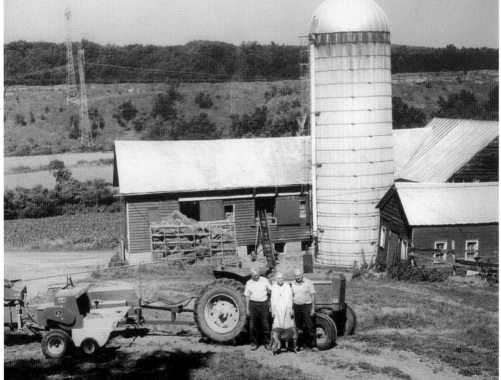

Bronk and Edgar Van Slyke, Van Slyke Family Farm

There once were hundreds of farms in Greene County. The Van Slyke family has been farming in what is now the town of New Baltimore for over 300 years. Their dairy farm is now operated by Bronk and Edgar Van Slyke. They milk about 25 cows. Today, it is one of only two dairy farms left in the Town of New Baltimore. Pictured left to right are Edgar, Vera (mother), and Bronk. (Courtesy of Van Slyke family.)

Aaron P. Flach
Flach has saved and rehabilitated many historic structures in Coxsackie. Born in Alcove, Albany County, he moved with his family to a farm in Coxsackie when he was six years old. After graduation from Alcove Christian Academy, he attended Pepperdine University and the College of St. Rose where he studied history and political science before joining his father's real estate firm at age 21. After buying some investment properties, he decided he wanted to rehabilitate historic structures in Coxsackie. His first major purchase in 2002 was the Eagle Hotel in downtown Coxsackie, which had last been used as a dress factory. After completing the rehabilitation and turning the structure into a high-end apartment house in 2004, Flach turned his attention to the old Coxsackie High School, which had gone unused for many years. Once again after a two-year effort, he was successful in making the structure a beautiful income-producing property. Over the years, Flach has tackled many other smaller old structures that he considered worth saving and turned their appearances into something pleasing to the eye. His company also owns many other newer rental and income-producing properties in the village. He says, "From an economic standpoint, the older properties are more of a challenge than newer construction, but turning them into something that beautifies the village is my passion." (Authors' collection.)

Lloyd and Mary Lou Zimmermann, Black Horse Farm

Black Horse Farm was started by Lloyd and Mary Lou Zimmermann in 1969. Prior to the establishment of the market, it was the site of the Black Horse Inn, which is believed to have been built in 1791 by Isaac Hallenbeck and is located along what was King's Highway, now State Route 9W, in the town of Athens. At the time it was built, inns of this type were located every two or three miles as places where travelers could stop and refresh themselves or spend the night. The inn burned in the 1950s, but the barn, which is the centerpiece of the current operation, is believed to have been built in 1856.

The Zimmermanns bought the property in 1965. Three years later, their daughter Chellie and a cousin Jim Amery set up a table and umbrella at the site and began selling fresh produce to local friends and neighbors. The next year, 1969, the family opened the doors to the barn and started selling flower and vegetable plants. Many expansions at the site have taken place over the years, and the Zimmermann family now farms hundreds of additional acres of land. Since 1990, the Zimmermann's daughter Lisa has also been active in the business. In addition to the retail space on Route 9W where they sell their own locally grown plants and vegetables, they run an extensive wholesale business from their home farm on Fountain Flats Road in Coxsackie supplying produce to major chain stores on the east coast. The Zimmermanns are proud of their tradition of giving back to the community. Through a partnership with the Regional Food Bank of Northeastern New York, they have donated fresh produce for several years. In 2010, Lloyd initiated a new program with the food bank wherein produce that does not meet aesthetic grade necessary for sale in stores would all be donated to the Food Bank. It has been estimated that annual food donations by the Zimmermann family help to feed over 244,000 people in 23 counties in New York State. (Courtesy of Mary Lou Zimmermann.)

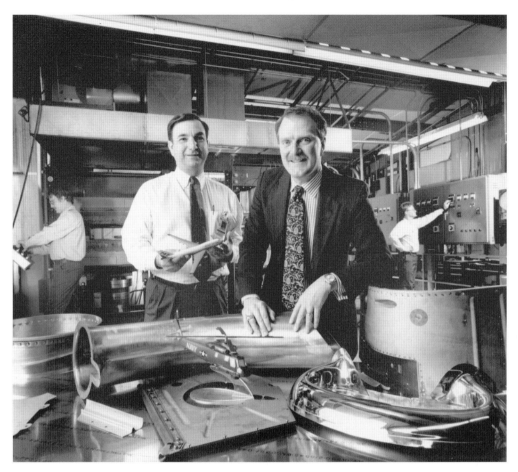

Hugh Quigley, Michael Grosso, and Paul Carpenter, DynaBil Industries
This Coxsackie-based business was founded in October 1977 by three brothers-in-law: Hugh Quigley, Michael Grosso, and Paul Carpenter. Thus, the origination of the name: DYNAmicBrothers-In-Law (DynaBil). Their goal was to fabricate structural components for the aerospace and defense industries. The company started by making bread racks for the interiors of Wonder Bread trucks manufactured by Grumman Olsen in nearby Athens. Their first aerospace customer was Sikorsky Aircraft. They contracted with DynaBil in 1980 to make sheet metal parts for Black Hawk helicopters. The business with Sikorsky grew over the years, and by 2008, amounted to $15 million a year in sales. DynaBil Industries became the largest supplier of titanium parts for Sikorsky and Boeing as well as a supplier of entire complex assemblies such as helicopter doors. In 1982, Carpenter left the business and Quigley and Grosso continued on. Over the years, they secured work from other companies such as Boeing, Northrup Grumman, General Dynamics, and Lockheed Martin. In 2005, the company was named the New York State Small Business of the Year. They were recognized for their innovative approach in dealing with the economic fallout from the tragedy of September 11, 2001. As a result of this downturn, all employees agreed to take a 25 percent cut in pay for three months to avoid layoffs. This team approach worked and has proved to be a model that has been imitated by others as an alternative to layoffs. In 2008, the company had grown to almost 300 employees. The partners decided to sell the company and began looking carefully for a business that would be committed to the community and stay in Greene County. Quigley and Grosso sold DynaBil Industries to Ducommun Aerostructures, Inc. The company remains in Coxsackie and currently employs 350 people. Pictured left to right are Michael Grosso and Hugh Quigley. (Courtesy of Hugh Quigley.)

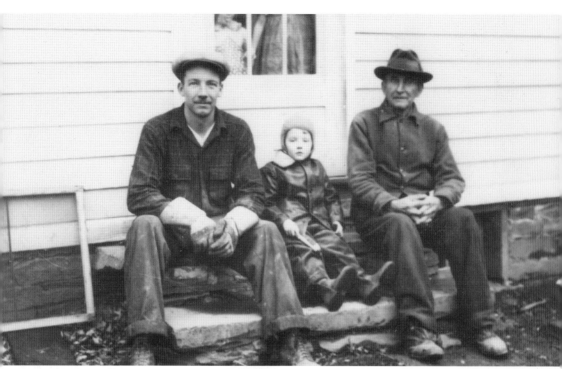

Charles and Rachel Story, Story Farms (1896)

Charles and Rachel Story moved from Freehold to the foot of the Catskill Mountains in 1896 to farm the rich flat land they found there. Their son Matthew and his wife, Virginia, started selling vegetables to the tourists as they passed by and also to the mountaintop resorts where they stayed. In 1960, their son Matthew Jr. and his wife, Margaret, added a roadside market and greatly expanded the farm. The fourth and fifth generations of the Story family now run the farm, which has added greenhouses and a pick-your-own operation. The stand sells any fruit, vegetable, and flowering plant that is in season, such as strawberries in the summer and apples, pumpkins, and mums in the fall. Pictured from left to right are Matthew, Matthew Jr., and Charles Story. (Courtesy of Story family.)

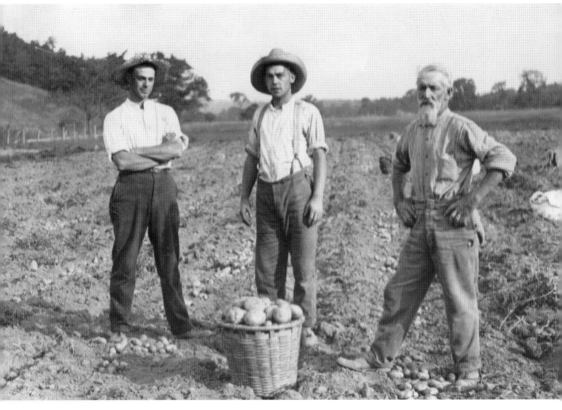

George Story, Story's Nursery (1956)

Story's Nursery was founded by George Story in 1956. His interest in growing plants started as a youth with a six-by-six cold frame while living in the hamlet of Freehold. That eventually led to a partnership with his father, Clinton, growing vegetables and plants—both vegetable and flowering—on his grandfather Ralph's dairy farm about a mile from the hamlet. The produce and plants were sold at a stand in Freehold and at the Menands Market. At that time, he began growing nursery stock on the farm as well. In 2000, forty-four years after establishing the nursery, Story sold the business to Kenneth Thompson. Since then, there was a major fire in 2006 that destroyed the building, and a flood caused by Hurricane Irene in 2011, which destroyed much of the nursery stock. Despite these two disasters, the business is still flourishing under the same name and continues to grow and expand. Pictured on the left is George Story. (Courtesy of George Story.)

The Stiefel Family, Stiefel Laboratories, Inc.

The company, which later became known as Stiefel Laboratories Inc., was started in 1847 by John David Stiefel in Germany as the J.D. Stiefel Company. The first products produced were candles, but within a few years of its beginning, the company began making medicated soaps. The company's products were brought to the United States by August C. Stiefel, J.D. Stiefel's grandson, in 1910 and renamed Stiefel Medicinal Soap Co., Inc. By 1914, Stiefel was producing 103 different medicinal soaps in Germany that were packaged in seven different languages. Between World War I and World War II, the company was out of business because of destruction during World War I. After World War II, Werner Stiefel, J.D.'s great-grandson who had attended Yale and obtained a degree in chemical engineering, with the help of his father August and his brother Herb, purchased an old creamery in Oak Hill, which they remodeled and enlarged. Downstairs were manufacturing, shipping, and a small lab. Upstairs were the offices and wrapping department (all by hand). The company had a slide to get the wrapped soap down to shipping and a hay bale elevator to get the pressed soap upstairs. Over the years, the company's product line grew and diversified beyond medicinal soaps and included all types of skin care products. Eventually Stiefel's network of distributors, subsidiaries, and manufacturing facilities in other countries allowed the company to manufacture and distribute products around the globe. In 2009, Stiefel was acquired by GlaxoSmithKline. As part of the acquisition, Stiefel Laboratories is now called "Stiefel, a GSK Company." Pictured above is Werner Stiefel. (Courtesy of Ned Stiefel.)

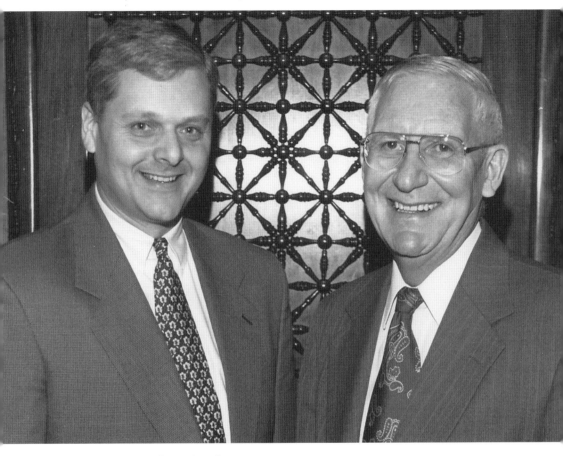

Alexander "Sandy" Mathes Jr.

After college, Mathes worked for state senator Charles D. Cook serving as his executive assistant for 16 years. During this period, he was also elected to the Greene County Legislature three times and served as majority leader for the last two. Working with government and community leaders, major accomplishments during his time included the rehabilitation of Catskill Point, construction of the new County Office Building, and construction of a new Fire Training Center. Soon after Senator Cook's retirement, Mathis became the first full-time executive director of the Greene County Industrial Development Agency—a job he held for nine years. His time at the IDA saw significant economic development success, including two business parks: Greene Business and Technology Park and Kalkberg Commerce Park on the Route 9W corridor in Coxsackie and New Baltimore. This was followed by the redevelopment of the long-closed Travco Business Park in Athens with Peckham Industries, and the reversal of the announced closing of the Stiefel Manufacturing Facility in Oak Hill. The site, which had been purchased by GlaxoSmithKline, not only stayed open, but was enhanced by capital improvements totaling over $100 million. During his time as executive director, the county also witnessed significant investment in the Hunter and Windham ski areas and commitment to open land preservation through mechanisms like the Greene Land Trust. Mathis now works in the private sector doing development and consulting. Pictured above is Sandy Mathis on the left with assemblyman Charles Cook. (Courtesy of Renee Mathis.)

CHAPTER SIX

Spiritual and Medical Leaders

Every community needs spiritual and medical leaders. Greene County has always considered itself fortunate to have people blessed with the needed talents to fill these categories. Spiritual leaders set examples for others, and they often possess charismatic qualities that make them stand out. People in the field of medicine are also fondly remembered.

Religious leader Rev. Johannes Schuneman was a feisty minister during the Revolution. He not only carried a gun on his rounds, but he persuaded people to support the rebellion. Rev. Henry Howard Bates entered the Civil War as a chaplain at age 53. Maggie Van Cott, who started preaching in a one-room schoolhouse in Durham, became a nationally known evangelist. Today, Greene County's people of the cloth are still making a difference, like Perry Jones who ministers to the homeless of the area.

In the field of medicine, Dr. Edwin L. Ford honed his skills at Andersonville during the Civil War and came home to provide medical care to the people of Lexington for several decades. Like most rural communities, Greene County was fortunate to have doctors like Dr. Charles E. Willard, who made house calls in his horse and buggy starting in 1874 and continued his selfless service until the time that a community hospital was established in 1933.

Although only a few of these hometown heroes can be mentioned in this book, the people of this county considered themselves fortunate to have many people serving in these callings today.

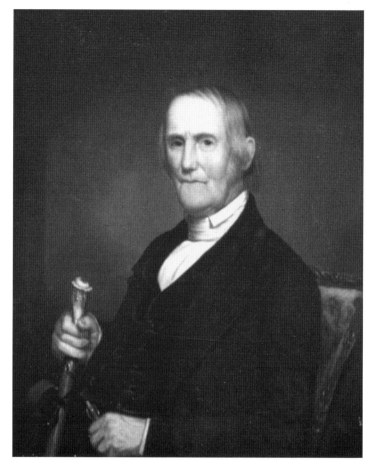

Johannes Schuneman

Schuneman, known as the Dutch Domine of the Catskills, was a well-known Revolutionary War supporter in Greene County. He was of Palatine German heritage and was born and raised in the Hudson Valley Dutch culture in the early 1700s. After two years of study in Holland, he shepherded two congregations—one in Catskill (Katskill) and one in Coxsackie (Kochshakie) for 41 years until his death in 1794. This arrangement required that he alternate his preaching every other Sunday between the Coxsackie church and the Catskill church located in what is now Leeds. He traveled by horseback in good weather and horse-drawn sleigh in the winter. The Domine's allegiance to the Colonial cause during the Revolution is well documented. He was the first of 220 signers of the Plan of Association in 1775. This document was one of the first formalized written complaints by residents of the American colonies against the British crown. It is widely believed that he played a role in getting residents signatures on the document because he was often out and about performing his pastoral duties. Beers's *History of Greene County New York* says, "He preached constantly the high duty of the strenuous defense, exhorted his neighbors and parishioners in behalf of the good cause, became a member of the local committee of safety, made his house a shelter for the few soldiers who passed by on their way to Skeenesboro and Saratoga, and a hospital when they came back sick with fever. His enthusiasm aroused the wrath of the Tories of the neighborhood, who would gladly have set the Iroquois upon him. But he went about armed by day, and slept—his menservants also—with his gun by his side, as his precaution and his-well known courage saved him from the fate of the Abeels (patriots who were kidnapped by Indians and Tories)." The Greene County Historical Society has the Domine's gun, "Old Peg" in its permanent collection. (Courtesy of Greene County Historical Society.)

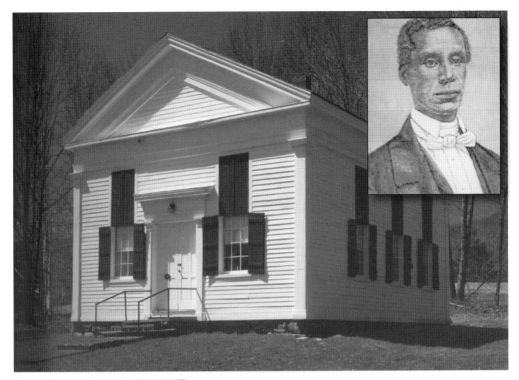

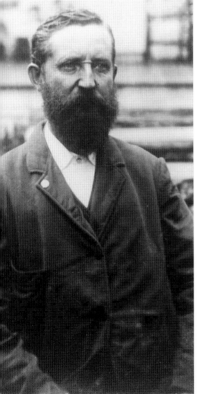

Francis Burns (December 5, 1809–April 18, 1863)
Burns, an African American born in Albany, at age eight was indentured to the Atwoods, a farm family in Ashland. He was allowed to attend the North Settlement Methodist Church. At 17, Burns felt a call to become a preacher. In 1834, at age 24, Burns left for Liberia to serve as a missionary teacher, and in 1858, he became the first black bishop in the Methodist-Episcopal Church. (Above, authors' collection; inset, courtesy of Francis Burns United Methodist Church.)

Edwin L. Ford (1842–March 19, 1927)
Born in the Town of Lexington, Ford joined Greene County men when he enlisted as a private with the 120th New York State Volunteer Infantry. Eventually taken prisoner, he was imprisoned in Andersonville, Georgia. There, he joined tens of thousands of prisoners in deplorable conditions. Ford managed to survive and returned to Lexington where he became a practicing physician using skills he had learned as a surgeon's assistant at Andersonville. (Courtesy of Donna Poulin.)

115

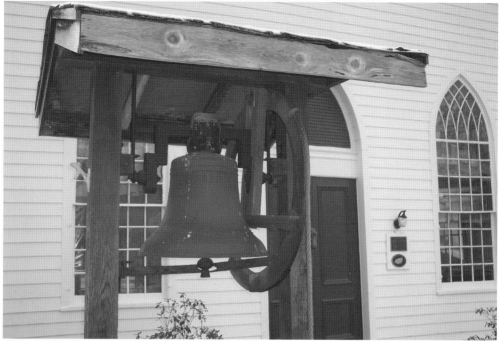

Henry Howard Bates (November 23, 1808–January 14, 1868)

Bates, a minister prior to the Civil War, joined the Union Army on July 4, 1861, at age 53. In poor health, he was mustered out on June 19, 1863. On Monday, April 10, 1865, while serving the Episcopal Church in Oak Hill, he learned the war was over and promptly tolled the bell for a half-hour to bring the news to the town's people. He died less than three years later. (Authors' collection.)

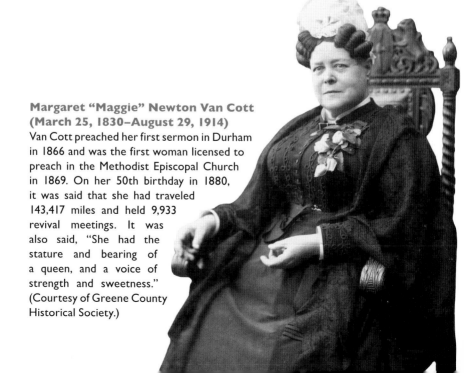

Margaret "Maggie" Newton Van Cott (March 25, 1830–August 29, 1914)

Van Cott preached her first sermon in Durham in 1866 and was the first woman licensed to preach in the Methodist Episcopal Church in 1869. On her 50th birthday in 1880, it was said that she had traveled 143,417 miles and held 9,933 revival meetings. It was also said, "She had the stature and bearing of a queen, and a voice of strength and sweetness." (Courtesy of Greene County Historical Society.)

John Porter

A native of Coxsackie, Porter graduated summa cum laude at both Davidson College and Johns Hopkins School of Medicine. He also excelled in sports. Both in 1980 and 1981, he was named first team Academic All-American in baseball. Porter served his country as a US Army surgeon with multiple deployments overseas. He is currently a professor of surgery, anesthesia, and emergency medicine at the University of Mississippi Medical Center in Jackson, Mississippi. He possesses a fourth-degree black belt in the Japanese martial art aikido and owns his own dojo. He is a published author, not only of over 100 scientific articles, but also of the book *The Tao of Star Wars*, which uses *Star Wars* motifs to explain the Chinese philosophy of Taoism. (Courtesy of John Porter.)

Charles E. Willard (1846–1935)
Willard came to Catskill in 1874. His obituary states in part, "Dr. Willard built up a large practice and was recognized as one of the best physicians in this section of the state." He was still alive when the Memorial Hospital of Greene County opened in 1933. His buggy, which he used to make many house calls, is now in the collection of the Greene County Historical Society. (Courtesy of Greene County Historical Society.)

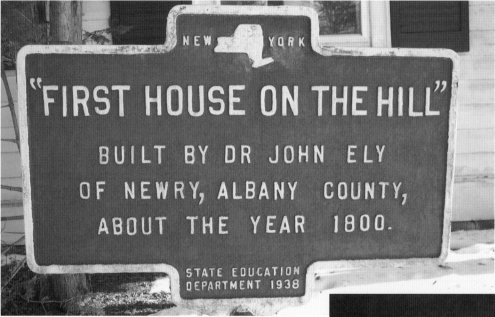

"FIRST HOUSE ON THE HILL"
BUILT BY DR JOHN ELY
OF NEWRY, ALBANY COUNTY,
ABOUT THE YEAR 1800.

STATE EDUCATION
DEPARTMENT 1938

John Ely (1774–1849)
During the War of 1812, Dr. Ely served as a surgeon. After the war, Ely established his medical practice and residence in Coxsackie. The street where his house is still located was later named Ely Street. The community held him in high regard, and in 1838 he was elected to the US House of Representatives, where he served from March 4, 1839, to March 3, 1841. (Courtesy of Greene County Historical Society.)

Cornelia P. Porter

Porter grew up in Coxsackie and graduated from the newly combined Coxsackie Athens Central High School. She received her doctorate in nursing science from the University of Arizona. Porter has held faculty positions at various Ivy League and Big 10 academic institutions. As a master educator and member of the National Coalition of Ethnic Minority Nursing Associations, she has mentored nationally and internationally doctoral students from diverse racial/ethnic backgrounds. Porter has conducted interdisciplinary community-based research in a variety of settings with "tweens" and adolescents, primarily from historically designated racial and ethnic backgrounds.

She has received many honors and awards. She was inducted into the prestigious American Academy of Nursing and served as chair of the Expert Panel on Adolescents & Young Adults. She was the first African American nurse to earn tenure and promotion in the 100-year history of the School of Nursing, University of Michigan, Ann Arbor.

Porter has published and presented extensively about race and the conduct of research with members of historically designated racial and ethnic groups. Her early publication in *Nursing Outlook* about research with Black/African American and Latino/Hispanic people is considered a classic. In 2004, her article "Race and Racism in Nursing Research: Past, Present, and Future," coauthored with Evelyn Barbee, was published in the *Annual Review of Nursing Research* (Vol. 22, No. 1), for which Dr. Porter served as volume editor along with Dr. Antonia Villaruel. Porter is currently a research scientist at the Research Foundation, University at Albany, SUNY. (Courtesy of Cornelia Porter.)

Perry Jones

As an eighth-generation resident of Greene County, Reverend Jones's seventh great-grandfather Benjamin Jones Sr. moved to Windham in the 1790s from Somers, Connecticut. Since then, Jones's ancestors have lived in Windham, Jewett, Hunter, Prattsville, and Tannersville. His ancestors fought in both the Revolutionary and Civil Wars.

Reverend Jones received his bachelor of arts in religion from Trinity College in Florida and his master's degree in theology from Grace Seminary in Indiana. He was called to be the executive director and pastor of Capital City Rescue Mission, Albany, in 1982 and ordained by First Baptist Church of Westerlo in 1987. Since he began to shepherd the homeless and poor in one small building, the Capital City Rescue Mission has grown to a nine-building campus providing over 600 meals a day to the hungry and 200 beds each night to the weary. The staff has increased from 1 to 45. The Mission also provides long-term recovery programs for men and women, a free medical clinic, learning center, and a clothing-giveaway ministry, Blessingdale's. A 125-year-old former shirt factory has been renovated and now houses the Transitional Living Program, offering 43 studio apartments. The Mission receives no government funds, but is privately funded by generous individuals, churches, and businesses. Pictured on the left is Perry Jones. (Courtesy of Perry Jones.)

CHAPTER SEVEN

Crime and Punishment

Like everywhere in the world, Greene County has never been immune from crime—even the most serious, murder. One of the first recorded in the new county was the murder of Sally Hamilton in 1813. Her killer, or killers, were never found and convicted, but a creek in Athens named Murders Creek is a continual reminder of her death over two centuries ago.

Before New York State took over executions for capital crimes, four men were hanged in Greene County for murders they were convicted of committing. One of the most heinous killers was Joseph Waltz, who murdered a scissor grinder who was spending the night in his parents' home. He also killed his guard on the day before he was to be hanged. Greene County even had its own state executioner who lived in Cairo and is credited with putting 137 people to death in the electric chair at Sing Sing prison between 1939 and 1953.

Greene County's isolation also made a convenient place for bootleggers to hideout during prohibition. One of the most notorious was Jack "Legs" Diamond who had a home in Acra. Diamond met his own execution—gangland-style—but his killers were never brought to justice.

Sally Hamilton (1793–August 25, 1813)

One of the earliest murders to be recorded in Greene County was that of Sally Hamilton, a young unmarried woman living with her father and sister in the northern part of the village of Athens. On August 25, 1813, she had been visiting another sister in the southern part of the village (about a half mile away) and set out to return home about eight o'clock in the evening. Assuming she had spent the night with her sister, Hamilton was not missed until the next day. A search was quickly organized. On the third day, after Sally Hamilton's absence, her body was found about half a mile "up the creek" just north of the village. Examination of the body indicated that she had struggled with her attacker or attackers, but in the end succumbed from blunt force trauma. According to the account, "It appears probable the murderers took the body to the bridge crossing, and from thence plunged it into the water and it drifted up the creek; or else that it was lowered down from the bridge into a boat and conveyed to near the place where it was found." Sally Hamilton was later laid to rest in the upper section of Mount Hope Cemetery in Athens. Two men, Patrick Cavanagh, and a soldier by the last name Lent, were tried for the murder at different times, but neither trial resulted in a conviction. In the end, the murderer or murderers were never found. Sally Hamilton's gravestone, which is barely legible now, reads, in part: "Sacred to the memory of Sally Hamilton, who was murdered by unknown hands in the evening of the 25th of August, A.D., 1813, in the 20th year of her age. Parental affection erects this monument." The creek near which the young woman's body was found has since been known as Murderers Creek. (Courtesy of Lynn Brunner.)

Joseph Francel
(September 2, 1895–January 25, 1981)
Francel lived in Cairo. When World War I broke out, he went to France with the American Expeditionary Forces and worked as a mechanic. Later in life, his official job title with the State of New York was electrician and he served as the state executioner at Sing Sing Prison from 1939 to 1953. He is credited with pulling the switch on the electric chair 137 times. His last executions were of Julius and Ethel Rosenberg, a married couple, convicted of conspiracy to commit espionage in 1951. (Courtesy of Cairo Historical Society.)

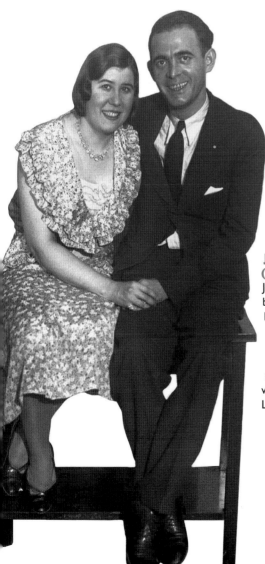

Jack "Legs" Diamond
(July 10, 1897–December 18, 1931)
Jack "Legs" Diamond, alias Jack Moran, was a bootlegger, kidnapper, and all-around tough guy. He survived at least four attempts on his life and maybe a few others that went unreported. Late in his short life, he established a hideout in Acra. Diamond's life ended abruptly when he was shot in a Dove Street rooming house in Albany. The killers were never found. Pictured on the left are Alice and Legs Diamond. (Courtesy of Patrick Downey.)

Joseph Waltz (c. 1851–May 1, 1874)

The day of his birth is not known exactly, but there is no doubt about the date of his death, as he was the last man to be put to death by hanging in Greene County. He was only 23, fair-haired with blue eyes, and on the surface appeared to be a quiet hard-working young man who lived with his family on the family farm located in Athens just over the town line with Catskill. His victim was Hermon Holcher, a scissors grinder who was staying at the farm with Waltz's parents. It was the custom in those days that people in Holcher's line of work traveled around the country sharpening scissors and knives and obtained lodging wherever they could—often in private homes. For reasons known only to Waltz, he rose from his bed during the night and killed Holcher with several hatchet blows to the head. When Holcher did not return home, his family began an investigation and traced the victim's movements to the Waltz farm. The sheriff then commenced his investigation, and finally when a letter was found describing the murder along with other crimes, which was proved to be written on paper torn out of a scrapbook found in young Joseph's room, Joseph Waltz confessed and led police to the spot on the farm where Holcher's body was buried. Young Waltz pleaded not guilty by reason of insanity. He said he was visited by evil spirits who urged him to perform more "grand, heroic and enterprising feats." He interpreted these spirits to mean—kill. He was found guilty and sentenced to be hanged in the Greene County Jail. The story does not end here, however. On the day before his hanging was to occur, he pried a strip of iron from the floor under his bed, fashioned it into a weapon and beat his jailer Charles Ernst senseless. Ernst died the next day. At the time of the attack on Ernst, a petition for Waltz's reprieve was pending with Gov. John Adams Dix. A message was sent to the governor detailing the recent attack on Ernst. Within 20 minutes, the governor telegraphed back, "No reprieve." He also sent two companies of soldiers to guard the jail overnight. Joseph Waltz was never tried for Ernst's murder and was executed in the chamber on the second floor of the jail the next day on May 1, 1874. He was buried on the family farm, as no local cemetery was willing to accept his body. Pictured above is a self-portrait of Joseph Waltz. (Courtesy of Greene County Historical Society.)

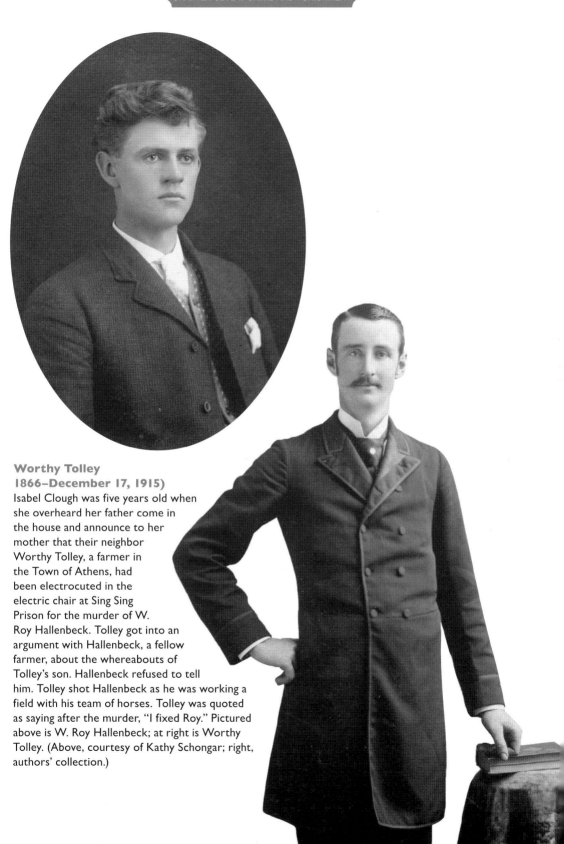

Worthy Tolley
1866–December 17, 1915)

Isabel Clough was five years old when she overheard her father come in the house and announce to her mother that their neighbor Worthy Tolley, a farmer in the Town of Athens, had been electrocuted in the electric chair at Sing Sing Prison for the murder of W. Roy Hallenbeck. Tolley got into an argument with Hallenbeck, a fellow farmer, about the whereabouts of Tolley's son. Hallenbeck refused to tell him. Tolley shot Hallenbeck as he was working a field with his team of horses. Tolley was quoted as saying after the murder, "I fixed Roy." Pictured above is W. Roy Hallenbeck; at right is Worthy Tolley. (Above, courtesy of Kathy Schongar; right, authors' collection.)

INDEX

INDEX

AN IMPRINT OF ARCADIA PUBLISHING

Find more books like this at
www.legendarylocals.com

Discover more local and regional history books at
www.arcadiapublishing.com